SLEEPING
WITH
DOGS

SLEEPING WITH DOGS

RIVA YARES
A Memoir

PRODUCTIONS

NEXT TURN

Scottsdale, Arizona

Next Turn Productions
3625 Bishop Lane
Scottsdale, AZ 85251

First Edition
10 9 8 7 6 5 4 3 2 1

ISBN: 978-0-615-47438-0

Library of Congress Control Number: 2011927636

Printed in Singapore by CS Graphics PTE LTD.

To Shelli and Dennis,
my children, my life.

This is not an autobiography, nor is it a book of recollections. In one way or another, I have used in my writings whatever has happened to me in the course of my life.

—W. Somerset Maugham

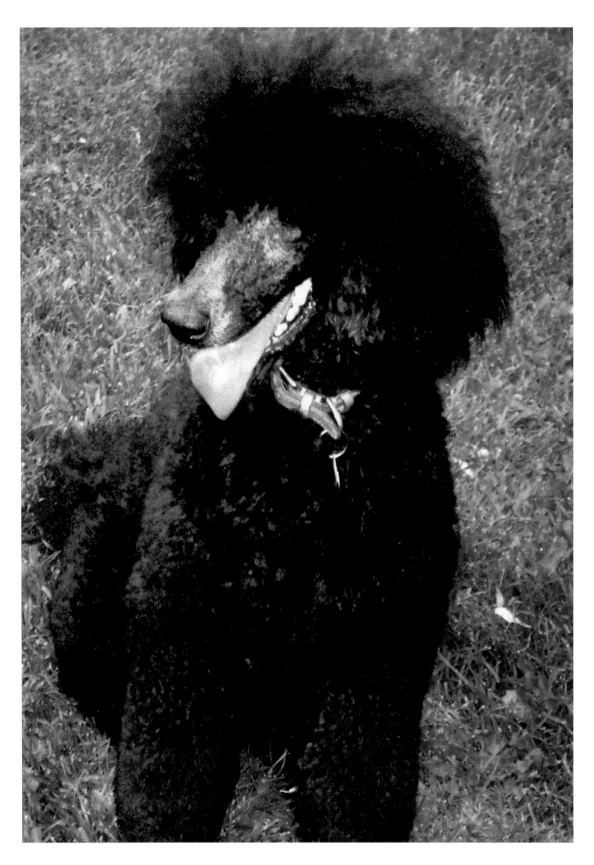

India, my Indian hunting dog.

PROLOGUE

Any woman who loves must know how to lose herself and find herself again.

I love men. I love dogs.

Since I was fifteen, men—young and old—have adored me. I would walk into a room and all eyes would be on me.

But the years go by. For a man, there is always someone younger, prettier—and willing.

The men disappear. The dogs stay. You and I end up sleeping with dogs.

Riva and Magnum *by Fritz Scholder.*

CONTENTS

Edward Lucie-Smith, a great English author and my friend.

INTRODUCTION

By Edward Lucie-Smith

The history of modern and contemporary art is a story of great dealers as well as of artists. One only has to mention the names of Vollard, Kahnweiler, and Leo Castelli. Without the efforts of these facilitators, modern art would not have evolved in the way it has. Perhaps, indeed, it would not have moved forward at all. It takes the perceptive eye of a great dealer to recognize a particular artistic situation and discern what it requires.

A famous story concerns the Russian impresario Serge Diaghilev and the French poet and playwright Jean Cocteau. When Diaghilev's Ballets Russes began to be famous in Paris, Cocteau longed to be accepted as part of this innovative team. He pestered Diaghilev with ideas, which Diaghilev kept refusing. Finally, in despair, Cocteau asked, "Serge, what do I have to do?" The reply came immediately: "Surprise me!" A great dealer, who is only an impresario wearing a slightly different hat, always hopes to be surprised.

This book celebrates a remarkable achievement and an even more remarkable personality—that of art dealer and film producer Riva Yares. Riva has looked for, and found, those surprises many times over. Sometimes it has been through the discovery of a new talent. Very often it has been through a fresh turn in the career of an already well-established artist. Her gallery has never been predictable. Over the years, it has shown both the great and classic names of contemporary art as well as other artists whose reputations were, at the time of their shows, not so fully established.

Riva's success has been even more impressive because she has never had a gallery in New York. Her base has been in Scottsdale, Arizona, with a second gallery in Santa Fe, New Mexico. The growing taste for contemporary art and the appearance of a generation of major collectors in Arizona have been intimately linked to the presence of her gallery in Scottsdale and later in the international destination of Santa Fe, New Mexico, where in 1991 she opened her second gallery and has her second home.

When she rebuilt her space in Scottsdale, Riva made a statement about the nature of her intentions: this is commercial gallery that has the look and feel of a well-run museum, and that presents its artists with all the panache of a public institution. There is, however, one important difference—no museum director actually presides over the gallery. Instead, Riva is a constant presence in the magnificent building she has created.

The newer gallery in Santa Fe is equally elegant—as indeed it should be, since the interior of the building was designed by a leading Minimalist architect with an international reputation, Claudio Silvestrin, designer of the White Cube in London.

Certainly none of Riva's success in the notoriously volatile art-dealing scene in the United States could have been predicted when she began her business as an Israeli newcomer with no money and no connections. Instead, her durable success came from three unique personal qualities. First, she possesses great flair and financial shrewdness, and she has backed the right artists at the right time. For example, it is almost entirely due to Riva Yares that Matta saw the revival of his career in America. She helped to make Americans see that Matta's *oeuvre* was not something exotic, imported from Europe, but inextricably part of the story of American art. Second is the sheer force of her personality. Every one of Riva's friends and clients knows that she is something akin to a force of nature—fascinating, capricious, unpredictable, and, in certain moods, not to be denied. To borrow a phrase, she has "a whim of iron." Third, and most important, is the fact that she is in love with art.

Loving art is rather different from liking art. It implies a hunger for visual sensations that has to be satisfied on a daily basis. For Riva, however, this hunger is linked to finely-tuned discrimination. She loves art, but she has no time for the second-rate and has been known to express her impatience in extremely forceful terms with works that seem to her not good enough. What is not good enough for her is certainly not good enough for her clients.

For those of us who know her, a grand capriciousness is very much part of her genius. I say "genius" because genius is more than charm, which of course she possesses in the fullest measure.

Edward Lucie-Smith
London, England
2010

Top: Scottsdale exhibition space. Bottom: Santa Fe exhibition space.

Top: Scottsdale board room. Bottom: Santa Fe office.

My penthouse.

My grandfather, Dov, at 100.

ISRAEL

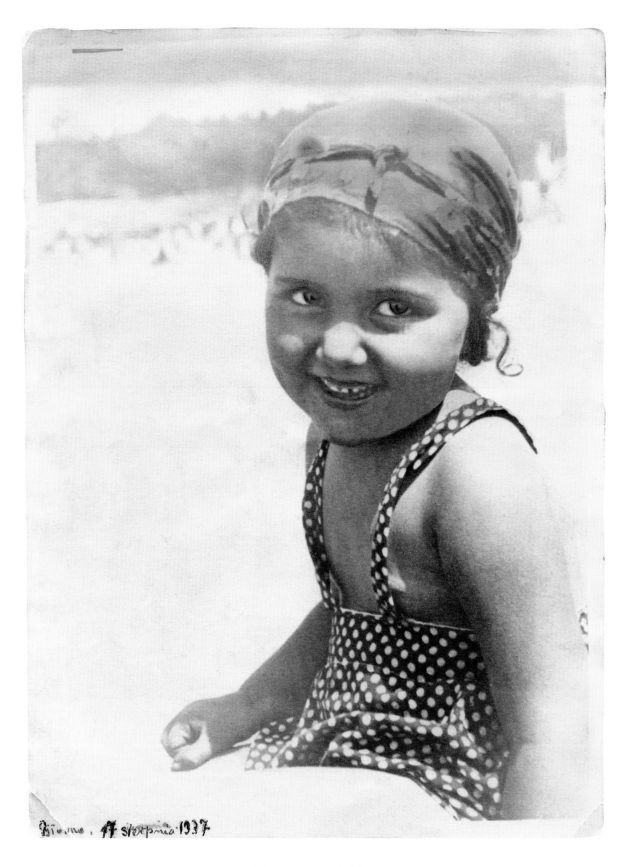

Riva, poster child.

I
POSTER CHILD

At the age of three I was a poster child advertising the new port of Tel Aviv in Israel. I was very beautiful, very dark from the sun—a symbol of this new country. There were posters and postcards of me everywhere in town. I was dressed in little shorts and a scarf, and the words, "The Port of Tel Aviv Would Live Forever" were emblazoned on the poster in Hebrew.

By the time I was five, I already knew that I was afraid of war. I asked my father, "What do they write in the papers when there is not a war?" I remember exactly what he said to me, "My child, there is always a war someplace in the world." I'd hoped that his answer would be different.

At that time, my father's father was a hundred years old, and my mother took me to Poland to see him for his birthday. He was a holy man, with a long white beard and a black satin yarmulke. He walked without a cane and read without glasses. People throughout the villages in the area where he lived believed that he could be in two places at once—to them he was mysterious and mystical. He could speak Hebrew. In Europe at that time, only holy men and rabbis could speak Hebrew.

From the first moment I saw him, I loved my grandfather. I remember holding his hand while he and I were conversing in Hebrew, as we walked in his small Jewish village of Bendin in Southern Poland. For the villagers, Hebrew was a sacred language. They all spoke Polish and Yiddish. I was kind of a miracle child to them, as I could speak Hebrew. The villagers followed us because they wanted to touch me, but I was a little thing and didn't want to be touched by these people who were speaking a language I didn't know. I was frightened of them. I held my grandfather's hand and knew that I would be safe. Once, he had said to me, "Nothing will ever happen to you, my child," and I believed him.

When my grandfather was ready to die, he went to all his friends to say good-bye. He told them, "God is calling me," and he died in his sleep. He was one hundred and thirteen years old.

In 2006, I felt a strong desire to go back to Poland and to discover my origins. I wanted to look for my mother's father's grave and also to visit Lodz, the city where my mother was born. I wanted to retrace my mother's steps from her house to the high

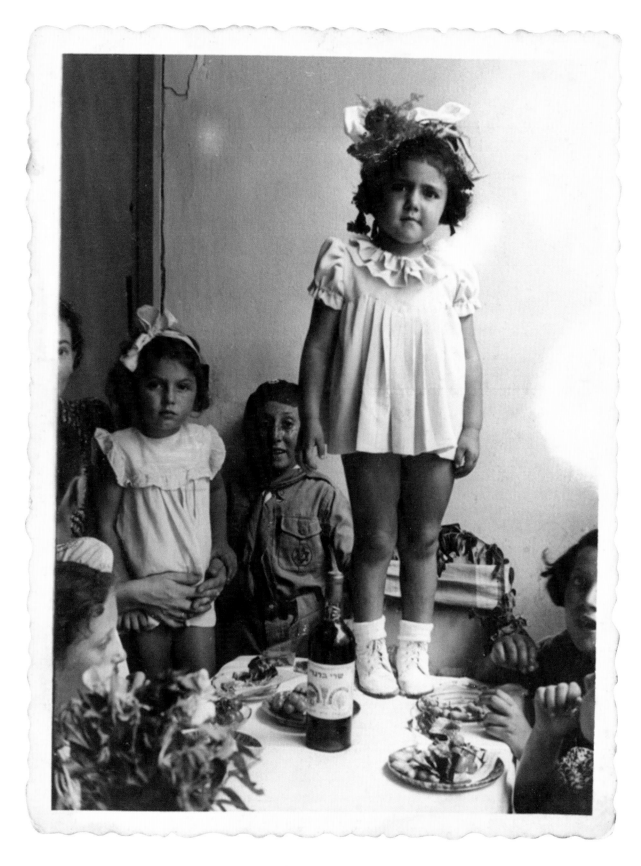

Riva, age 3.

school had attended. Today, Lodz is the center of Polish cinema and looks very modern with large hotels and cafes. Several of its museums show contemporary art, and at the time of my visit there was a large and impressive Goya exhibition.

When I was a young girl, my mother wanted to tell me about growing up in Poland but I would never listen to her stories. When she died, I felt very bad that I knew so little about her life. I did know that she had grown up in a wealthy family with servants and that her father had been a very tough and domineering patriarch. His first wife, who had died young, left him with six children; his second wife, my grandmother, had two children with him, my mother and her little brother. My mother told me that when she was four years old, her mother had died. I later learned from cousins in Toronto that my beautiful grandmother had actually run away from her domineering husband to join a band of gypies, and her death was a lie to protect my mother. My mother's brother eventually became the wealthiest man in Lodz. But wealth offered no protection from the Nazis. He died of hunger in a concentration camp.

In Bendin, the village where my father was born, I went to look for my beloved father's father's grave. The small village of Bendin was quite different from Lodz. Its streets were unpaved and it was a depressing place, a scene of devastation. I couldn't find my grandfather's grave. Most of the headstones had been broken up, destroyed by the Nazis. I picked up a small stone and placed it on a headstone with no name, to signify that I had been there to visit him.

At the graveyard was a middle-aged man dressed in a business suit. He was using some gardening tools to clean a headstone and the debris around it. I spoke to him in the little Polish I knew from my childhood, asking him what he was doing. He told me that this was his parents' headstone. He said that he hadn't been very good to them when they were alive and this was all he could do for them now.

I stood there and cried. It reminded me of my relationship with my parents.

Even now, when I tell the story, tears fill my eyes.

My mother, the most elegant lady in Tel Aviv.

My father, the gentleman.

Thirteen people were killed in this building on Marmorek Street in Tel Aviv as a result of a bombing by Facist Italy on June 12, 1941.
Photo from http://bajurtov.wordpress.com/category/historia/page/3/.

II
BOMBING OF TEL AVIV

At the start of World War II, Tel Aviv was a new business and cultural center on the Mediterranean coast of Israel. We had opera, theater, cinemas, a symphony hall, and many artists whom my father would come to know. The people in the city came from all over the world and brought their culture with them. My parents were Ashkenazi Jews, Zionists who came from Poland to help build the country in the early 1930s. My father had the visa and my mother had the money, so they got married.

The apartment building where we lived when I was five years old was in a very nice area of town, near a big park and City Hall, which was the heart of Tel Aviv and a target for Italian bombers during World War II. Our building didn't have a bomb shelter. We lived on the third floor, so when we heard the air-raid sirens, we would walk down the stairs and sit on the first-floor steps.

When my parents went out to play cards with their friends, they had left me alone. They always left me alone—no babysitter, no sisters or brothers. I had only the little green men from my dreams, who would come down and keep me company. I can still see them now—these entirely green people—three-feet tall, with green skin, green clothes, and large black bulging eyes. They didn't talk; they were very busy taking care of things and being my imaginary babysitters. They were funny and made me happy in this empty apartment.

When my parents would leave for the evening, they would tell me that if I heard the air-raid siren, I should put on my bathrobe and go wake Reuben, our tenant. This was not an easy assignment, as Reuben snored like a train and slept like the dead. Then we would go down and sit on the stairs until the bombing was over.

In the middle of the night, sitting on the stairs, I could hear the whistle of bombs, then the explosions. I felt so relieved and fortunate that I wasn't the one being hit. I had to touch myself to make sure I was still alive.

Sometimes, when I was alone during the bombings, I would sneak into the first-floor apartment. This belonged to my parents' friends, whose sons were the two premier basketball players in Israel. During the air raids, I felt safe hiding under their beds, where it was dark, small, and secure.

I remember one night when many of the people in our apartment building ran across the street, as that building had a shelter. I was very young and didn't dare do

anything but sit on the steps. In the morning, I saw many dead bodies on the road. The people who had run across the street were hit by a bomb. It was the first time I saw dead people. It had a profound effect on me.

Another memory from that apartment is my fish story. My mother insisted that we bathe only once a week, on Friday. On Sunday, the big market day in Israel, she would go to the market, buy a live carp, bring him home, fill up the bathtub, and let him swim there for the rest of the week to make sure he would still be fresh for the Sabbath meal on Saturday. Friday, she would cut up the carp to cook. Then she would empty the bathtub, and we could finally take a shower after the fishy water was drained, although the scent remained. I didn't think we smelled funny, because we all smelled the same.

My father and mother, Fishel and Sala Kilstok.

III
MRS. BERMAN

My mother was a nurse who had studied to be a doctor. One of the first volunteers with the new Israeli army, she started the nursing school at the military hospital called Tel HaShomer. She wore a uniform and was given a high rank. Every morning at seven o'clock she was picked up by an army driver, and she was gone until six in the evening. When she was in uniform and we walked together in the streets, soldiers would salute her. This amazed me, the respect she received. To me she was just my mother.

My father, who owned a large factory, loved artists and supported them. At lunchtime he would come home, then at four or five in the afternoon, after siesta, he would go to Café Cassit. All the Tel Aviv artists would go to this café. Our house became filled with their work, as that was how they would repay my father for the money he gave them. My father was truly a patron of the arts, always insisting on supporting the struggling artists of Tel Aviv.

I loved my father and wanted to be with him as much as possible. During summer vacation, I wanted to work in his factory as his secretary. His office was a glass cube in the middle of the huge factory floor, where he could see everything that was going on. I wanted to sit with him, be with him there. But he said no, there were too many men around.

So that I wouldn't be alone, every day after school I was supposed to cross the street from my house to the home of a family friend, Mrs. Berman. My mother had nursed Mr. Berman until he died. That is how the friendship developed between the two women.

Mrs. Berman was a Russian aristocrat who always wore a long black satin dress, with long strands of pearls. She had beautiful white hair pulled back into a loose bun. When I arrived there from school, the first thing she did was to serve me tea with lovely little sandwiches, and somehow I learned manners from her. However, she bought me clothes that I hated, putting me in taffeta dresses with big ribbons in my hair.

She didn't speak Hebrew, but she spoke German, Russian, and French, as well as many other languages. Some of my knowledge of languages came from her. She was extremely intelligent and knew much about music and literature.

Bernie the composer said, "I was always in love with you and still am."

Her two adult sons lived with her. One was a composer named Bernie, and the other son, Victor, was just a big guy who didn't work but hung around the house.

Bernie the composer was about thirty at that time. He taught me how to play the piano and treated me like an adult, which I liked. His room in their big apartment was a headquarters for Lohamei Herut Israel, or Lehi ("Fighters for the Freedom of Israel"), an armed underground Zionist organization fighting for the formation of a Jewish state. The British referred to it as the Stern Gang, after its founder, Avraham Stern. It was the smallest and most extreme of Israel's three underground groups, with only a few hundred members. Yitzhak Shamir, who would become Israel's prime minister in 1983, was one of its leaders. Its goal was to forcibly evict the British and allow unrestricted immigration of Jews to Israel.

In Bernie's room was a secret radio station. One frequent visitor was a young woman named Geulah Cohen, who years later would become a minister in the Israeli government. She had an incredible voice and was the station's broadcaster; she was the Tokyo Rose of Israel. In 1943 she was arrested by the British and sentenced to nineteen years in prison. She later escaped and continued to broadcast.

I was twelve, sitting in the corner of this room, very quiet, watching what was going on, all very secretive, finding it very, very exciting, almost like walking on a tightrope. It was a nest of anti-British activity, and if the British found out about it, they would have arrested everyone. The great lady Mrs. Berman of course knew about it, but we never spoke of it. In the rest of her big apartment everything was very elegant—the dishes, the furniture, the curtains—like a Russian palace—but in this one room was the secret radio station.

Years later, when I was married and had two children, I visited Israel, which by that time was a free country. I met with Bernie the composer and asked him what I had been like as an adolescent. His answer astonished me. He said to me in Hebrew, "You were just wonderful and I was madly in love with you and still am."

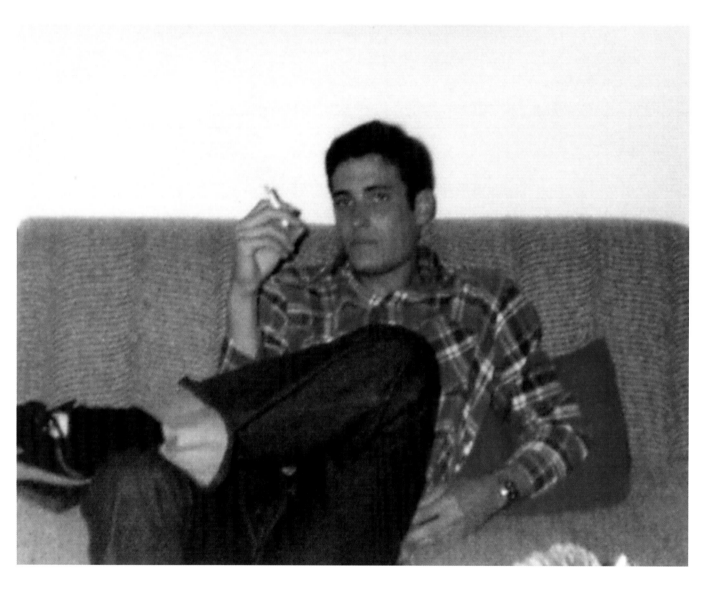

My cousin, Chaim.

IV
AVRAM, THE MOVIE THEATER
and
DANCING WITH GOATS

After my birth, my mother went to a resting home, as was the custom at that time. There she met a woman called Rachel, who had a year-old son named Avram. The two ladies decided that Riva (nine days old) and Avram would one day get married.

I grew up with Avram. He lived on a farm, where his mother raised chickens and his father ran the only movie theater in the village. For three months every summer, I would visit the farm, called Kfar Sirkin. In the morning, Avram and I would gather eggs, and at night we operated the movie theater. This movie theater was actually a barn with straw on the ground, benches, and a screen. Avram worked the projector, and I ran the subtitles, which were on the side of the screen. The movies were American, mostly Westerns. Farmers dressed in overalls would come to this barn-cinema after long days of work. Occasionally a flock of chickens would march through the theater. I loved it, and I knew then that one day I would make a movie.

All day long we had lots of fun. We sang and danced with the goats, putting makeup on each other and costumes on the goats. We had trunks full of costumes, and he and I and the goats performed plays for empty benches. The two of us were so much alike.

Growing up, we saw each other in the city, had dinner, had fun, slept together, laughed and cried together. We were not lovers but were more like brother and sister.

Some years later I left the country, went to Arizona, and opened a gallery in Scottsdale. Avram stayed in Israel and opened a gallery in Jaffa.

Avram and I did not get married, and we lost touch, unaware of our similar lives in the world of art. Thirty years later, he came with his boyfriend to visit me in Phoenix.

My cousin Chaim lived in Jerusalem with his mother, Nechama. Chaim's father was a prisoner of war. In 1944, his father had enlisted in a special brigade that the Jews who lived in Palestine formed to fight the Germans. A few days after he enlisted, he was sent overseas and was captured by the Germans.

Chaim and his Polish mother lived in Jerusalem within a compound of immigrant Jews, most of whom had managed to escape from Iraq. Their houses were made of stone, and the people lived there quite primitively. Even though they were Jews, they lived like Arabs: They spoke Arabic, they ate Arab food, and they dressed like Arabs—the women wore long embroidered dresses and scarves on their heads.

Once a week they baked very large pitas in the outdoor wood oven in the compound's courtyard, and they would divide the bread among the families who lived there. These huge pitas would be stored, rolled in a sheet, high in a pantry, until it was time to bake more.

Nechama was a little five-foot-tall Polish woman who ran the whole show. She lived without her husband, only the little boy Chaim, who had asthma. I would go to visit them often. I liked very much what was going on in this courtyard—all the yelling and laughing, and a kind of Arabic yodeling that sounded like it came from the streets of Baghdad.

I would stay there for a week or so on school vacations. Chaim and I roamed the fields, looking for land mines. It was our idea of fun. Like all the kids around us, we were troubled by the war. We never played with toys; we played war.

To this day, Chaim and I are in touch. When my daughter Shelli went to study in Israel at the age of fifteen, she lived with his family.

V
I AM RECRUITED

It was spring and I was eleven years old. One day, as I was walking home from school, two serious-looking young men approached me. Not wanting to draw attention to themselves, they fell into step with me and asked if I would be willing to join the Irgun (Irgun Zvai Leumi). This was one of the three Israeli underground groups fighting against the British, the occupiers of Palestine.

I told them yes, as I was afraid to say no, even though I knew how dangerous it was and how upset my parents would be if they found out. I didn't tell my parents, or anybody else.

The two men said there would be a swearing-in near the Tel Aviv Zoo at six in the evening. I took the bus to the zoo as the light was fading, and when I got there, I could see a bonfire in the distance. Other kids my age were there, perhaps a dozen of us. We didn't talk. We stood together in a little group. I think we all must have been frightened. I was. I was so young.

When we got closer to the bonfire, the two men who had recruited me blindfolded us. I heard a deep voice commanding, "Do you swear to defend your country with your last drop of blood?" I said yes. I was no longer afraid. I felt like a grown-up. I really believed every drop of my blood would be drained from my body.

After the ceremony, I was completely under the sway of the Irgun people and would do anything they ordered me to do. I was brainwashed. I was so young.

Thus it was that, at the age of eleven, my life was already a secret. I was a member of the Israeli underground, and two or three times a week after school, on the orders of our eighteen-year-old leader Yariv, a group of six kids would meet in an abandoned schoolhouse. We'd break in through a second-floor window, and Yariv would be waiting for us.

There we would have training sessions. We learned how to use Uzis, handguns, and hand grenades, as well as how to assemble and disassemble them. We were told to shoot first if someone came after us. And shoot only the enemy—the British soldiers.

We would always follow Yariv's instructions, no matter what. I believed everything he said: "Go to this street, to this address, you wait for this man with a yellow shirt, shoot him, run."

I was the only child of sociable parents. They went out every night to play cards with friends or go to a party or the movies. I would be in bed in my pajamas, pretending to be asleep. When I heard the door close behind them, I would get out of bed, take off my pajamas, get dressed in the khaki clothes that I'd hidden in a space behind the closet, and sneak out.

The six of us kids would meet, dressed in scarves to cover our faces and khaki hats, called *cova tembel*, pulled down over our eyebrows. Only our eyes were showing. We'd sneak into a movie theater, go up to the balcony, and throw anti-British propaganda pamphlets down into the audience. Some nights we would poster the walls of the city. Two of us would walk in front, as scouts. The third kid would apply the paste, and another would put up the posters. And the last two would walk behind, as guards.

Recently, my friend Arden asked me, "How do you brainwash a very young person to become a terrorist?" My answer: "Children of eleven or twelve believe that when they are asked to give the last drop of blood for their country, they really believe that the blood comes out of their body—that you sacrifice yourself for your country."

What makes a young soldier in the underground? Why did they choose me? I was an only child, lonely, alone all the time. I walked two miles to school, two miles back. They probably watched me and knew this, and that was why they picked me out. I was perfect for the Irgun. And at eleven, I was the right age, as British law didn't allow soldiers to incarcerate children under seventeen.

The people in the Irgun were very serious, and they treated us as grown-ups. I liked that.

I was never a teenager—and I'm still looking for my teenage years.

Instead of going to school, I started going to the park near my house, hiding my schoolbooks, and taking a bus to the other side of town. I was going to the Irgun meeting place, where they would tell us what we would be doing for the rest of the week.

When I had missed school for an entire month, the school called my parents to ask if I were sick. Without my knowledge, my father followed me. He took the same bus and I didn't see him. He didn't confront me; he just went home and told my mother.

When I came home, my mother chased me around the table with a leather army belt. She was chasing, I was screaming, she was chasing, I was screaming. My mother shouted at me, "You'd better go to school tomorrow or I'll kill you!" She didn't catch me, and she didn't kill me.

After a few months as a member of the Irgun, I'd become completely dedicated. I was twelve and I didn't know what fear was.

One day, four British soldiers were found hung on trees outside of Tel Aviv. It was an act of revenge for their killing young Israelis. In response to the hangings, the British declared a curfew. They took all the Israeli men in town, aged seventeen to eighty, to a park and surrounded it with barbed wire. The women and children were allowed to stay at home but were not to leave their houses. Schools, stores, and public buildings were all closed. Loudspeakers throughout Tel Aviv broadcast: "Whoever leaves their houses will be shot."

I faced a big dilemma. I had been ordered by my Irgun superiors to deliver a package to Shankin Street. On the way there I would have to cross Allenby Street, one of the main streets in Tel Aviv. Large numbers of the British soldiers known as Red Berets, paratroopers who had a reputation for cruelty, were gathered at the main intersections along Allenby to enforce the curfew.

Steeling myself, I snuck out of my house to make the delivery. I passed stealthily from house to house, stopping next to every wall. When I reached Allenby Street, I heard shouting in English. I was still some distance away from the soldiers, but they had seen me. They commanded, "Stop, or we will shoot!"

I began to run as fast as I possibly could. They ran after me and started shooting. I heard the bullets whiz over my head and felt them pass between my legs, but I kept running. I ran until I got to my destination. I pounded on the first door I came to, but the people inside were afraid to open it. I ran to the third floor, where I was supposed to deliver the package. The Irgun people there opened the door just as we

Poster based on anti-British pamplets of my childhood.

heard soldiers running up the stairs. I was ushered into a bed, covered with blankets, and given a compress for my head. The soldiers forced their way into the apartment. But what they saw was a sick child in bed. They didn't recognize me; they thought I was one of the family members. Finally they left to search the building, and I waited under the covers.

Now I faced the problem of how to get home. My parents didn't have a phone. Only doctors and government workers were allowed to have phones. The Irgun people in the apartment were very kind to me, and I told them my problem. They came up with the strategy of calling the MDA (the Israeli Red Cross), who were sympathetic to Irgun. They called for an ambulance by yelling to a neighbor with a phone. A very sick person needed to be transported. And that's how I got home—on a stretcher.

All the neighbors watched from their windows as I arrived in the ambulance. When the medics brought me up the stairs to our apartment, my mother screamed with fear. She thought something terrible had happened to me.

I wasn't afraid of the bullets. It was my mother's screaming that terrified me.

Many years later, living in America, I was very active in an AIDS-prevention organization. We knew that HIV testing was key to stopping the spread of AIDS. People were afraid to get tested for the virus. They did not want to know. I went back to my childhood in the Irgun and our anti-British pamphlets. My friend Turner and I designed posters encouraging people to get tested for HIV. We printed ten thousand of them, and one winter night about nine hundred volunteers postered the city of Phoenix. When Phoenix woke up the next morning, the walls were covered with graphic posters proclaiming, "Get Tested!" No one knew who was behind the action, and it didn't really matter. Hopefully, some people got the message.

The Atelena. *Photo from Libraries-Rutgers.edu.*

VI
THE *ALTALENA*
and
CAFÉ MEOW MEOW

In 1948 the British Mandate of Palestine was ending, and Israel was struggling to become a state. On May 14, Jewish leaders declared Israel's independence and set up a provisional government under Prime Minister David Ben-Gurion. Ben-Gurion established a national army, called the Israeli Defense Forces (IDF), but rival Jewish groups still fought for power. The Irgun, the paramilitary group I had been a member of, now led by Menachim Begin, was the largest of them.

The Irgun purchased a cargo ship in Europe, naming it the *Altalena*. The ship carried a thousand refugees who had survived the concentration camps of World War II, along with Irgun volunteers and large quantities of guns and ammunition for their cause.

On June 20, when the *Altalena* arrived just off the coast of Tel Aviv, Ben-Gurion demanded that the Irgun turn over all their armaments. Begin refused. From the Tel Aviv beach, Ben-Gurion gave orders to shell the *Altalena*. At four in the afternoon the shelling began, and the ship started to burn. There was the danger that the fire would reach the munitions in the cargo hold and the ship would explode, so people abandoned the boat, jumping into the water. The captain flew a white flag to signify surrender, but the IDF forces continued firing, even upon the survivors in the water. After so many battles against the Arabs and British, Jews were firing against Jews. It nearly sparked a civil war. Sixteen Irgun people were killed in the confrontation, ten of them on Tel Aviv beach. Most of the refugees survived and scattered throughout the country.

At that time I was living two blocks from the beach. When I looked out the window, I saw black smoke and heard the guns. Even though I was still a child, I was affected so strongly, was so disturbed, that I put a pillow over my head so as not to hear the shelling. I cried and cried all day, feeling the suffering of the dead and wounded.

Ben-Gurion ordered the *Altalena* to be sunk in Tel Aviv harbor.

Menachim Begin.

Although I'd been an Irgun member for a number of years, I had never actually seen the elusive leader Menachim Begin. Only a dozen people in his headquarters actually knew what he looked like, as he always wore a disguise—a beard, a wig, dark glasses, or the costume of a religious Jew. The *Altalena* incident was the first time that he showed himself in public.

One day in 1949, on my way home from school, I happened to walk by Tnuva, a little vegetarian restaurant. There he was, sitting by the window. For me, it was the impossible dream. I walked into the restaurant and asked for his autograph. He looked at me, smiled, and signed his name in my schoolbook.

Menachim Begin

In Tel Aviv, where it was the custom for women to go to the cafés in the afternoon, my mother and her Polish-speaking girlfriends would go to one particular café. Some of the Polish women who had survived World War II would also gather there, and they'd reminisce about the beautiful past and what they had before the war.

There is a word in Polish that sounds like "meow." It means "I used to have." One woman at the café would say, "Meow, I had twelve servants." Another would say, "Meow, my husband was a doctor." It wasn't important if what they said was true—they may have had nothing before the war. But they would say that they had a great deal. We younger Israelis made fun of the place, calling it "Café Meow Meow."

These same people would come to stay in our house when they first arrived, and my mother would give them clothes. Some of them were survivors of the *Altalena*. I remember even giving away my bed for the night and sleeping on the floor. You had to take them in; where else would they go? They had survived the concentration camps. They had nothing but the clothes on their backs and black marks on their legs from wounds that had not healed.

Later on, the government provided housing for such people, but not then.

And when Israel became a state, it sent large ships to bring the wanderers, the displaced, and those still hiding to the new Israeli state.

VII
MR. ISRAEL
and
MAX, THE DIAMOND SMUGGLER

When I was fifteen, I fell madly in love with Mr. Israel, the most handsome man I'd ever seen in my life. He ran a big gym in Tel Aviv and was a body builder. I had seen his beautiful picture on posters with the name of his gym. Intending on meeting him, I began going to his gym, and we soon developed a relationship. There was something very soft about his face and eyes. He was a religious Jew. And, by the way, he was married and had three children, which didn't bother me a bit. We could see each other only in the evenings. We went for walks by the ocean and had long philosophical discussions.

After a couple of weeks, he agreed to meet my parents in a café. I remember the name of the café like it was yesterday. It was called Ginat Yam, the Ocean Garden, and was close to the sea.

There we sat, Mr. Israel, 27, Riva, 15, and my mother and father. Very proudly, I announced that I was going to drop out of high school to become Mr. Israel's assistant at the gym, as I loved him. My mother looked at my father, my father looked at me, they both looked at Mr. Israel. My mother said, "No, no, no," and they left.

So I went back to high school the next day and didn't see Mr. Israel anymore.

<center>***</center>

Max was a wealthy tourist who had come to Israel from Belgium. Everybody in Tel Aviv loved Max. He threw his money around and gave big tips, so he was especially loved by waiters and taxi drivers. He was twenty-seven. I was seventeen. I met him at a nightclub, where he bought me a drink and wooed me like everyone else he met. Even my mother adored him, as he sent two-dozen red roses to the house every Friday. I guess he was in love with me. A real party boy, he had a great sense of humor, and I had a wonderful time with him. He told his friends that he and I were engaged.

One afternoon we went swimming in a hotel pool. I was in the water with him, and suddenly I was in the midst of one of my worst nightmares. Max was drowning.

I wanted to scream, "Help!" but nothing came out of my throat. Men jumped into the pool, trying to pull him out. While they were attempting to resuscitate him, I just couldn't be there. I ran as fast as I could and hid behind a bush. I was actually praying, "Please God, don't let him die!" Well, Max died at twenty-seven. His heart blew up.

I don't know how I got home, but somehow I did, and the next day my parents took me away to a resort in Mount Carmel. The first thing in the morning, the police arrived there to question me about Max. I told them what I knew, and it was then that my parents and I found out that he was actually a criminal and was wanted by Interpol. He was a diamond smuggler, working from Belgium to Israel.

Thinking back now, I was almost a widow at the age of seventeen, as I was sure I was going to marry Max.

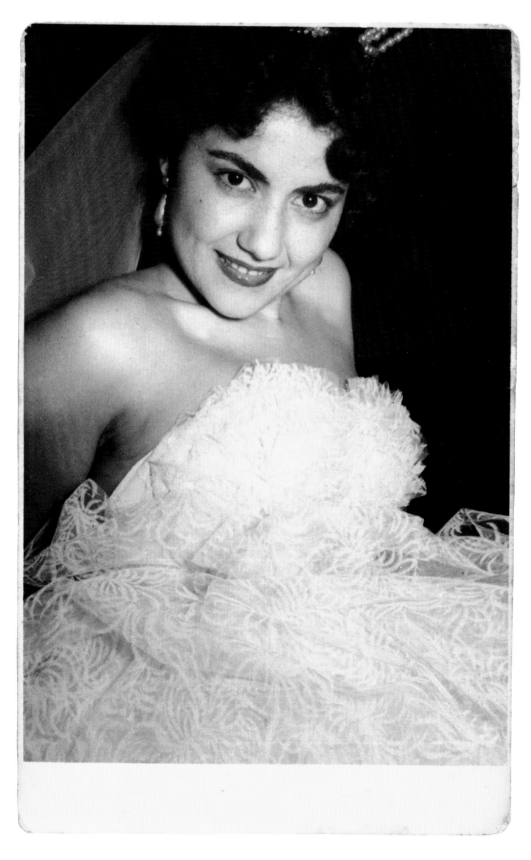

The young and foolish bride.

VIII
THE GREAT MISTAKE

After finishing high school, I looked for a summer job. I could speak some English, as it had been my second language in school, so through a friend of my parents I went for an interview at the JDC (American Jewish Joint Distribution Committee). This was an agency that provided relief and support for Israel and for Jewish people around the world, and I deeply hoped I would be able to help them with whatever they needed.

In the small room where I was interviewed were a few American men. I locked eyes with one of them, a man called Sam, who had been sent to Israel as an economic advisor. He was from Rutgers University, where he was a professor of economics. To me, a movie buff since my time at the farm, he looked like Alan Ladd, having similar very blue eyes and light hair. Of course we fell in love, and it was a grand summer. I didn't work much.

His appeal to me was mainly his power—his brain and his position. He drove a big white Ford, which I found enticing. There weren't many Fords in the whole country.

He was a married man with three children. His wife and kids had come from America to stay in Israel for the two years that he had the job with JDC. Sam eventually divorced his wife, left his kids, and married this young, beautiful *sabra*. I was eighteen; he was thirty-eight.

Sam is the father of my two children, Shelli and Dennis.

But too late I realized that I did not love him.

For our honeymoon, my American husband and I went to Cyprus, an hour's flight from Israel. On the way to the airport, I stopped the car, got out, and vomited in the road. At that moment, it felt like I was throwing out my marriage. In my heart I knew it had been a mistake—one that now, once I had it, I no longer wanted. I got back into the car, said nothing to Sam, and we continued to the airport.

In Nicosia, we stayed at the Ledra Palace Hotel, a brick, Venetian-style hotel that resembled the desert landscape and city in its color. The hotel was full of British soldiers, and late at night we heard a bomb explode. From my experiences as a youth in Tel Aviv, I thought it was a bombing from the sky, and I instinctively wanted to flee downstairs to safety. In reality, it was a hand grenade that had been thrown into

the courtyard of the hotel. This occurred at the beginning of the uprising against the British in Cyprus. At that time, Cyprus was divided—half Greek and half Turkish—and was ruled by the British.

From Nicosia, Sam and I went to Kyrenia, an old fishing village and seaside resort on the north coast. I became very friendly with the Greek family who owned the hotel where we stayed, and we conversed at length about the political situation in Cyprus. I sympathized with their longing for freedom from the British occupiers, since, of course, my whole youth had been devoted to helping Israel become free of the same imperialists.

Some time later, I came back to Kyrenia, this time without my American husband. I went back and took a room at the same Greek family's hotel, and they asked me to attend their clandestine meetings on the Greek situation in Cyprus. The idea of being involved in more political uprisings was exciting to me, but the driving force behind my involvement was knowing that I could help these people achieve independence from the same people I had fought against in my youth.

It was during this visit that my great love affair almost happened. About eleven o'clock at night, I heard a knock on my door. When I opened it, a very handsome young American was standing there. This tall, blonde man was in a panic. He grabbed my hand and led me to his room near mine. There a very pale older man was lying on the bed. He looked like he was near death.

The sick man, it turned out, was a Harvard professor. The young man was traveling the world on a scholarship and had just graduated from Harvard. He thought that his mentor had had a heart attack. He didn't know what to do, and he hoped that perhaps I could help. The only help I could give was to lift the man's head high on a pillow so that he could breathe easier and call the hotel doctor. As it turned out, the professor had sunstroke.

But between the young American and me, it was a love connection at first sight. He immediately adored me, and I adored him. From the first moment, he couldn't let go of me and asked me to travel the world with him. He wouldn't believe me when I told him I was married.

Of course I did not go with him to travel the world. But I spent the best three days of my life with him.

Looking back now, I see that this could have been the beginning of a great love affair. Not pursuing it was the biggest mistake and regret of my life.

IX
BLACK TURKEY

When Sam completed his two years at JDC, I didn't want to move to America. So he became an executive for an American paper mill in Israel. The mill had to operate seven days and seven nights a week without stopping.

This created a problem. The religious party was very powerful in Israel, and they didn't allow Jews to work on the Sabbath. Sam came up with a brilliant idea—he hired a whole Arab village to work on Saturdays. The Arabs adored him, and Sam was very kind to them.

One time, when they found out that he was sick, a delegation of twenty sheiks came to visit him at his sickbed. I was not prepared for this grand visit. When I looked out the window of our big house on a hill, I saw the sheiks walking up, their black *jalabiyas* blowing in the wind. They were leading a black turkey on a leash. When they finally got to the house, one of them picked up the turkey in his arms, went to Sam's room, and offered the bird as a talisman to speed his healing.

I served them black coffee. They wished Sam a speedy recovery and went on their way.

Only God knows that I didn't know what to do with the turkey. I named her Lulu and tied her to a post in the back yard. At first the dogs chased her, the turkey clucking madly. Then I became attached to Lulu. I couldn't kill her, I couldn't eat her. I finally gave her away to a farm.

Although I was an Israeli, I never felt any animosity toward the Arabs. I grew up in a tolerant family, and despite all the wars and political conflicts, I always got along well with the Arab people.

When I was a child, my father took me along with him to an Arab village. Arabs worked for my father, and every Friday he would take a horse and carriage to the village to pay the workers. The carriage driver rang a chain of bells and the villagers came to get their money, as I sat in the carriage and watched. Later we stayed overnight with the sheik, who lived a large tent, where we slept on rugs. The tent smelled like mutton—everything smelled like mutton. The women didn't eat with the men, but as I was a little girl, I was allowed to stay with my father.

The meal was a ceremony. The host tore cooked chickens apart with his hands and put a piece on each guest's plate. He hovered nearby as the others were eating;

when someone ate their chicken close to the bone, the host would grab it away and put a new piece on the plate. This really frightened me, but I later learned that it was considered good manners. The old Arabs smoked *narghiles* (hookahs, waterpipes), and my father gave me a taste. It did not taste good.

Between Arabs and Israelis there has always been a love-hate relationship. They killed our friends, and we killed their people. But individually it was different. We still broke bread with them when we could.

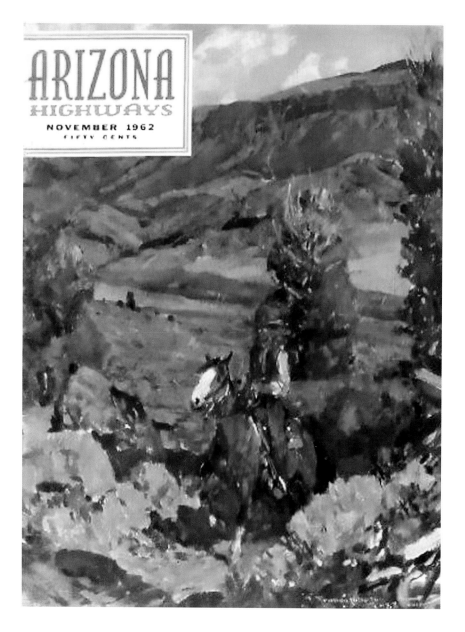

Arizona Highways, *November 1962. Courtesy of Arizona Highways.*

X
ARIZONA HIGHWAYS

When I was ready to marry Sam, my mother the drama queen told me that she objected and that she would kill herself if I married him.

After a few years, when I told her that I was planning to divorce Sam, again she said she would kill herself.

So the best thing I could do was to leave Israel, go to a faraway country, and not reveal what I was doing, like a teenager running away from home.

I happened to pick up a copy of the magazine *Arizona Highways*, which tells the story of Arizona. It featured photos of Sedona, the red-rock country. I fell in love with that place of beauty, cowboys and Indians, John Wayne, and other heroes of the silver screen I remembered from my childhood in Avram's movie theater. I thought Arizona was a state that Israelis would not go to, as they would prefer the glamour of Los Angeles and New York. My mother would not know my doings, such as divorcing Sam, which according to her was a big sin.

So I came to Arizona and committed the big sin. I divorced Sam.

Actually, there was a much greater reason to leave the country than my mother's prejudices. It was to save the lives of my two little children from the bombs continually falling on Israel. We were living outside the big city. When we heard the air-raid sirens, I would take my children and run to the trenches. There were no shelters, and the trenches were the only places to try to survive the bombs. I didn't want my children to be hurt by the continuous violence.

I hoped that in America the war would be behind us.

From the Middle East to the Southwest.

AMERICA

Red, white, and blue Riva.

XI
GOING TO AMERICA

Riva, Sam, and the two young children, Shelli and Dennis, boarded a Greek ship, the Olympia, at the Israeli port of Haifa, destination New York. It was a long trip, even though we were in first class. First class had ninety people; second class had a thousand. We stopped in Lisbon, Athens, and Naples to visit and to pick up passengers. We would get off the ship and tour each city for the day. It took three weeks to arrive in New York.

I'd never been on a ship before. It was quite boring, as most of the passengers were rich Greeks with whom I could not communicate. The main memory I have is that every day we had safety drills, and I hated them. Also, it had become obvious to me that my life with Sam was over.

One bright day I hurt my foot, and they sent me to the ship's doctor. He was young, tall and dark, dressed in a white uniform, and he looked like a Greek god. Of course I fell in love with him. He didn't speak a word of English, and I didn't speak a word of Greek. I guess my foot hurt a lot, so I went to see him every day. When I was with my Greek god, I was so much in love that I forgot, if only for the moment, that I was married with children.

Our arrival in New York is somewhat vague to me, but I remember staying with Sam's family for a few days before we took a flight to Arizona. They were very religious Jews. I hated staying there. I had nothing in common with these people. And it was obvious that they were angry at Sam for leaving his wife and three children for a young Israeli maiden.

When we arrived in Phoenix and walked off the plane, John Wayne was not waiting for me at the airport, nor were Indians with feathers running in the street—it was just hot, hot, hot.

It was a very difficult time for me. I didn't know anybody, and even though I was married to Sam, I didn't really know him or make an effort to know him. There was such an age difference between us, and I was so young. Although he was very kind,

we couldn't communicate. I'd want him when he wasn't available. When he was, I didn't want him anymore.

Sam got a job in Phoenix. He bought a house there, and I suppose it was in a good school district, something I knew nothing about. He knew some people in town and encouraged me to invite the wives for a luncheon, because that was how it was done in America.

The luncheon was in my newly decorated house. I'd used a lot of bamboo, thinking maybe I was on some Indonesian island. The rug was green and looked like grass. The only piece of furniture in the large room was a low black Chinese table, surrounded by pillows. I'd also discovered an American delight, something I'd never had before. I thought the best thing God had ever invented was Kentucky Fried Chicken. So for the luncheon, I went out and bought buckets of it and all the things that came with it. Also, I'd never seen paper plates, and I thought it would be a good idea to serve the Kentucky Fried Chicken and fixings on paper plates.

At twelve o'clock eight women arrived, dressed in suits and nylon stockings in the summer. Politely, they all sat down on the pillows on the floor. Of course I didn't serve wine because we never had wine for lunch in Israel. We had Coca-Cola—I was familiar with that. And very proudly I announced the luncheon menu. I told them that my very favorite food in American was Kentucky Fried Chicken, and that's what we were having. I guess this was okay with those women, as I was an Israeli and had come from the boondocks, from Israel, which had just been put on the map. This was my first and last formal luncheon the first year in America.

When that idea for my socialization didn't work, Sam bought me a set of golf clubs. He told me I must play golf if I wanted to have any friends. After my first golf lesson, I decided I didn't like golf and didn't want anything to do with it. I put the clubs in the back of our yellow-and-brown station wagon, the kind with wood on the sides, left the car unlocked, and prayed to God that the clubs would be stolen.

My prayer was answered. I didn't play golf anymore.

XII
SINGLE MOTHER IN AMERICA

One of the reasons I was in America was to divorce Sam. I'd concluded that I couldn't live with him anymore. I thought he was a good man, but I was restless for new adventures. The divorce was difficult, as he didn't want it. He wanted to keep me. He said I belonged to him; he'd given up a lot to have me. I was still very young, and my thoughts and dreams didn't make much sense in the real world. But they made sense to me.

When he said no to a divorce, I took my two young children and moved into my girlfriend Lori's house. I didn't even pack a suitcase. Obviously, I was very naïve. I didn't think you needed money to live in America.

I got my divorce and custody of the children—Sam didn't want them. I didn't know anything about child support. I just wanted out. I wanted to be free of living in a box.

Sam got visitation rights for a couple of hours every Sunday, but the children didn't want to spend time with him. They didn't like him very much, mostly because they were very attached to me. When he would come to pick them up, they'd hide.

Now my kids and I were one.

I did not know what it meant to be a single mother, especially in a foreign country with no family and little money.

In the past, I was never without money. Now, after a few days living alone with the kids, I realized that I needed to find a job. I figured out that there must be Jews in Arizona, as there were Jews all over the world. I had no profession, so my thought was that I could teach Hebrew in a synagogue and still be with my children.

Well, I got a job as head of a Hebrew school in Phoenix. Kids came in the afternoons to learn the language. This is what their parents wanted for them, but the kids themselves were not very interested. However, I made learning Hebrew fun, and this made the children and their parents happy. The parents would tell me that their kids would come home from elementary school, put on clean shirts, and be very excited to go to Hebrew school.

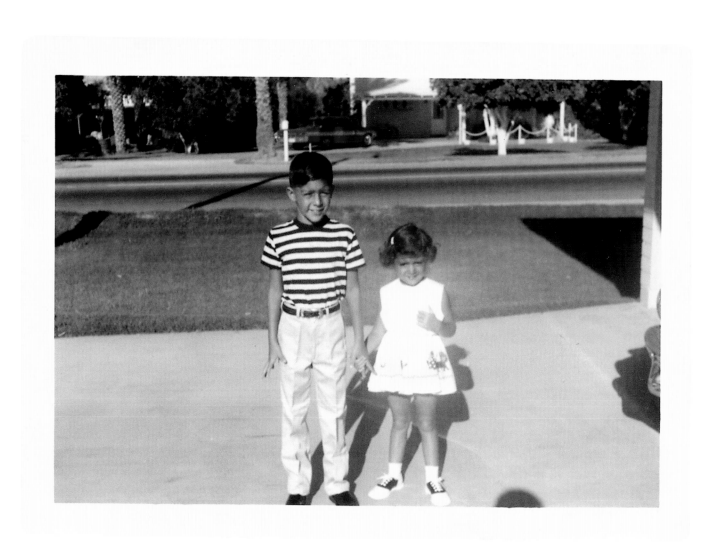

My children, Dennis and Shelli.

I did the job quite well and it worked for me, as my two kids would be in the classroom and I wouldn't have to leave them alone at home. As a mother, I always felt that my children were part of my body and I couldn't be away from them. I had no choice in the matter. This was my reality.

Ours was a very large reform synagogue. The rabbi came from Chicago, and he was young and handsome. Of course he was married with children. He fell in love with me, or he wanted me. We began a secret and forbidden love affair. Now, this was bad. He rented a little house in the desert as a place for us to meet and make love.

Memory bites.

It went on for quite a few months, maybe six. This man of God got me very excited. When I listened to his sermons on Friday nights and closed my eyes, I always saw him making love to me, which he did very well.

Of course this was eventually discovered. It was such a fiasco that he was fired, I was fired, and the temple was closed for good.

And this was the end of the holy love affair.

So again I looked for a job. In the newspaper I saw an advertisement for a nightclub hostess. I thought it would be good to work at night, as I didn't want be away from the kids during the day. When I went to the club for the interview, a big fat sloppy man with a cigar invited me into his cruddy office. I said I was from Israel. He was very impressed and told me he was Jewish. He said the nightclub was a strip joint. I had no idea what that meant, as there was no such thing in Israel. He explained what a strip club was, saying, "You're too good for this. It's no place for a nice Jewish girl." I thanked him, walked out, and cried.

I suddenly realized that one wrong turn can change your life. If I worked in a strip club, I'd probably be dead by now. So I took a turn to the right, not to the left, which actually saved me.

The model-actress.

XIII
LIVING THE BOHEMIAN LIFE

My secret desire in Arizona was to marry a cowboy, have a horse ranch, and ride into the sunset. I saw myself on a black horse, in a black hat and black riding gear. This seemed so real to me and so possible—romantic and practical at the same time.

In Israel I used to go horseback riding, as it was very fashionable. I felt quite comfortable on a horse until one day when I was riding and a group of very fast and loud motorcycle riders came up behind us. The horse went berserk. It galloped over the motorcyclists and wouldn't stop, until finally I threw myself off under a tree. I walked the two miles back to the stables, leading the horse behind me.

In Arizona, the first time I went out with a cowboy I couldn't stand his smell. It was a mix of yellow grasses and cattle. And then, when I visited his ranch, I realized that I was now afraid of horses. That was the end of my ranching future.

At that time, parts of Scottsdale still seemed to be a part of the Wild West, attracting conmen and runaway heiresses. Second Street was then a barrio. It was lined with olive trees and Mexican bars that workers frequented in their dirty clothes after work. They would drink too much and dance with the fancy women who had escaped the East. These heiresses would come there for cocktails and excitement. It was quite a sight. This was the Wild West, but not as I had imagined it. It wasn't Gary Cooper in *High Noon*.

I was always interested in theater. We had a pretty good one, called the Phoenix Little Theater. I got involved, made friends, learned theater makeup, and performed on stage.

The first play I did was *Teahouse of the August Moon*. I was a peasant woman and my kids played peasant children, so I could look after them. We brought a few goats onstage too.

Nick Nolte.

Another peasant was Nick Nolte, who several years later became a big star. I don't know whether this was due to his great talent or because one of the goats peed on his leg.

About eight of us would come to my house. None of us had money, but we had a lot of fun. We rehearsed plays, read poetry, and lived "the absurd." When it came time to eat, we would go to our favorite place, Durant's, a steakhouse on Central in Phoenix—a hangout for businessmen. We ate and drank wine with absolutely no idea of how we'd pay for it. By the luck of the draw, someone would walk in and ask, "Can I join you?"

"Of course, you can join us." There was always someone who could afford us. We were good-looking and interesting, and we didn't wear cowboy hats.

We were so naïve and so young. We respected and admired one another, and didn't have a single thought for tomorrow. For me this was freedom—no machine guns, no shelters or trenches. No husband. At last I was in America and happy.

In order to become a citizen, I had to study American history and pass the test they gave me. Then came the swearing-in ceremony, for which I was required to bring a witness, someone who'd known me since I entered the country. My witness was Nick Nolte.

I went to pick him up at his apartment, and as usual he wasn't ready. He was lying naked on a serape. I said, "Nick—you're not ready!" He said, "Yes, I am." He got up and wrapped himself in the serape—and that's how we went to the courthouse. And Riva became an American citizen.

Nick Nolte was the man who did so much for me when I needed help. We were like a family of nomads. When I needed to move, he carried my furniture and all my belongings in his little sports car. Nick and I had very good times. I miss him.

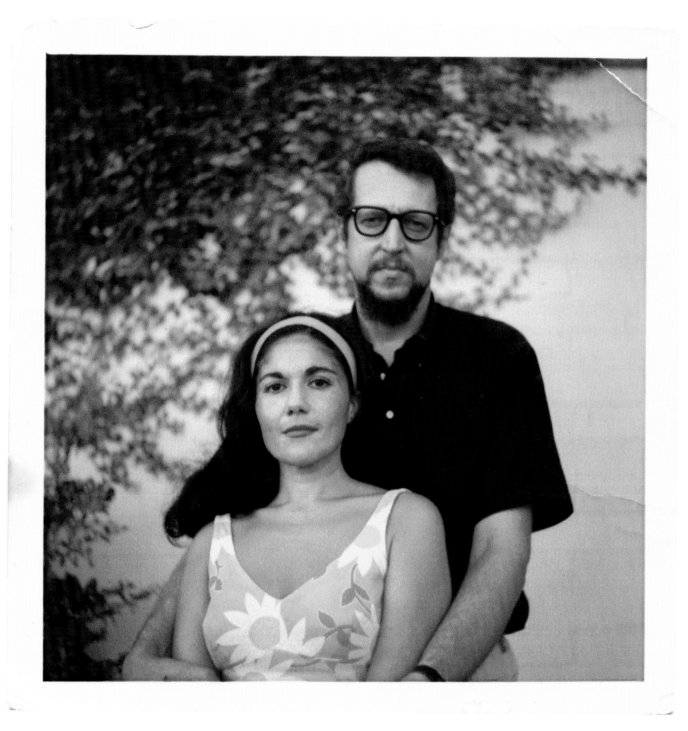

Second husband, Clare. A very tall and quiet dog.

XIV
CLARE

I met Clare Yares at a dinner party. He was a television director—quiet, very intelligent, with a great sense of aesthetics and very tall at six-foot-five. And he was a single father with four boys—ages five, seven, nine, and eleven.

He invited me to have dinner at his house and meet his boys. I was very impressed by the way he treated his children, and I thought that he would be a good father for my kids.

Not long after we met, Clare and I decided to open a gallery together. We called it the Yares Gallery. We found an old adobe house on Main Street that we fixed up, and at that time the kids and I lived in rooms in the back. Clare decided that he wanted to be an artist—working with his hands, making mobiles and sculpture—and I would be the gallery mistress. I had some education in contemporary art, but I didn't realize that Arizona in the 60s was the wrong place at the wrong time to open a contemporary art gallery. All the galleries in town showed pictures of western landscapes, cowboys and Indians.

The big day came, the opening of the gallery. It was a Sunday. Sam came to pick up the kids for a couple of hours. I was in the gallery—champagne and beautiful people—opening the first contemporary gallery in Scottsdale, Arizona. Not famous yet, my good friend Nick Nolte was my bartender for five dollars an hour. He was great.

When Clare and I had known each other for six months, he came out of his studio, walked over to me, and said, out of the blue, "Let's get married."

I said yes. But I wasn't in love.

He put a sign on the gallery door, "Going Fishing," and we went to the courthouse and got married.

I still don't know what marriage is.

The beginning (with my father).

Trying to do things right this time, I took his name and he adopted my children. However, after six years of marriage, Clare and I grew apart. I guess he didn't like those months when I was taking care of the artist Lew Davis, who was very sick.

Clare came up with the idea that we should sell the gallery and divide whatever we got down the middle. My answer was absolutely no. I wanted to keep the gallery. It was my life—my past, my present, and my future.

I told him he could have anything he wanted, but the gallery was mine. He took the dishes, the books, the music, the kitchen table. I was left naked.

A divorce is a divorce.

After the divorce, I was starting my life again.

I would get up at five in the morning to be the maid and clean the gallery. Then I would go home, clean myself up, dress, go back to the gallery, and be the mistress of the arts.

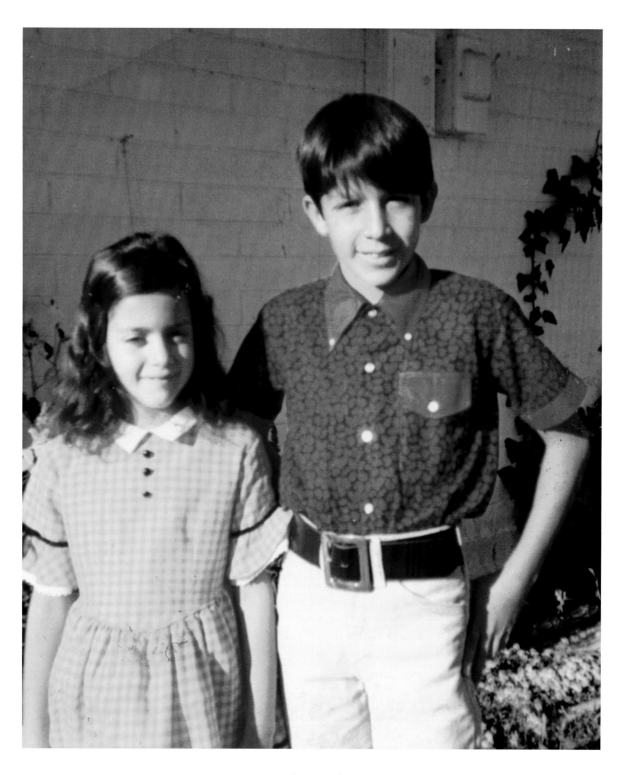

Kidnapped!

XV
JERUSALEM NIGHTMARE

After the big day, the opening of the gallery, Sam never brought the kids back home. No telephone calls from him, no messages. We looked everywhere—the police stations, the hospitals, news reports of car accidents—there was no sign of them.

I completely lost my mind over this terrible incident, as the kids were my life, and for the next three days a doctor had to put me under sedation.

Then I got a call from my father in Tel Aviv, saying that he'd seen Sam in Israel. Sam had lied to him, saying I didn't want the children so he'd dumped them at a children's camp on the border of Jerusalem and some Arab village.

This sign that my children were alive and well gave me strength, and I told my father that I would come to Israel to get them. I understood that Sam took the kids in order to get me back, as he knew that I couldn't live life without them. He knew that, once I was in Israel, the Israeli government would make it difficult for me to remove my children from the country. They were American citizens, but they had no identification with them.

I went to an international lawyer in Phoenix and told him my story. I needed direction about how to get the kids back. I had no money but said that I would somehow pay him later. He was very smart, very kind, and very interested in my story. We contacted Washington through an Arizona senator, and the story went through Washington like wildfire. At that time it was an unusual case, kidnapping one's own children.

I got word from my attorney that if I could somehow get my kids from Jerusalem to the Tel Aviv airport, the American consul would be there waiting for us. He would have certificates that would allow us to get back into America and prevent the Israeli authorities from detaining us, as my children had no passports. But this all had to be done very expeditiously.

My father and I had a plan. We rented a Jeep and drove near the camp in the mountains near Jerusalem, then we hid behind bushes and rocks so we could see the movement of the kids inside the camp. The first day we didn't see anything, so we slept in the Jeep. It was a cold, difficult night. Shivering for hours and holding onto my father for comfort, I was filled with trepidation about the impossible mission ahead.

The next morning, we saw a group of children heading to the swimming pool with the camp counselor. Among them were Shelli, age six, and Dennis, age ten. From this distance I watched my kids getting into the pool. Then I pulled on a bathing suit and, without thinking, hurried over to the pool, opened the gate, and got into the water. The camp people thought I was one of the counselors.

I grabbed Shelli and Dennis. Shelli was in my arms, and I took Dennis by the hand. We ran barefoot, in our wet suits, as fast as we could through the trees and bushes, over sharp rocks and stones, our feet bleeding, without looking back, until we got to the Jeep. I was so exhilarated to have them with me again that I felt no pain.

I quickly dressed the kids in clothes and shoes that I'd brought with me, and I threw a coat over my wet bathing suit. Hearing the whistles of the camp people, who had realized that the kids were missing, we sped off, driving about a hundred miles an hour.

I called the American consulate, and when we got to the airport, as planned, the consul was waiting for us with our documents and plane tickets. Still without shoes, I pulled the coat over me and we got on the plane.

Those moments before the plane left the ground were very intense.

We flew to London, making a stop at the London airport. I was shaking, still very wet. I was fearful that we'd be taken off the plane, but I didn't let the kids know how I felt. We talked and joked and told stories, like always. Nothing happened to us on the plane, no disasters, and we flew back to America. We had tickets for the next flight to Arizona, which was our home.

The next day in Phoenix I again met with my attorney. The mission was accomplished. He was very proud of me. He didn't want money because he knew I didn't have any. But he wanted to sell the amazing story to *Newsweek* magazine. Well, I said absolutely not, as I didn't want to scar my children's future by having this experience in print.

This was my Jerusalem nightmare.

XVI
MY SON, DENNIS

After being in Arizona for a number of years, I missed Israel and was considering moving back there. But first I just planned a visit, going there as a tourist with my children. Dennis was fifteen, and Shelli was eleven. By this time I was an American citizen.

At that age, Dennis wore his hair straight and very long, down past his waist. He looked like an Indian right off the reservation. He wore a headband, and he made me sew suede patches on his jeans. Shelli was a pretty girl and very smart.

Dennis was a young filmmaker. His passion was to make films. Every day after school, he worked very hard in the kitchen at the House of Pies in Phoenix. He wanted to save money so he could buy a movie camera. The owner liked him but told him that he couldn't work there with long hair. So Dennis went out and bought a five-dollar wig. It was quite funny and pathetic at the same time. Every time he took a pie out of the oven, a little bit of wig caught on fire.

When he saved enough money, he quit his job and bought the movie camera, which we took with us to Israel. After we arrived at the Tel Aviv airport, we took a cab to my parents' house, and he left his camera in the cab. He cried and cried. He had lost his life savings.

The next morning, there was a knock at the door. The taxi driver had come to the house to return the movie camera that Dennis had left in his cab. Only in Israel.

After a few months, I went back to Arizona with my children, as Israel no longer felt like home. Dennis continued his interest in filmmaking.

Many years later when I made my first major film, *Jolene*, Dennis wrote the screenplay based on an E.L. Doctorow story.

In Dennis Yares's words—

I have often said that my mother has never compromised to gain anything; therefore, she has never lost anything. Within the vast world of art, she has emerged as a woman of integrity, intuition, and intellect. She has been a progressive pioneer by introducing modern and contemporary art to the West. She has been diligent in

With my children, Main Street, U.S.A.

establishing and further developing the careers of those artists she respects and represents. She has created theaters of art with stages that resonate with color and light, where the artists are the cast that have painted the dialogue of her life.

My mother's greatest attribute is her discerning eye—an eye of unparalleled discovery. She has said that the secret of her success lies not in selling paintings, but rather in her ability to obtain great paintings, for great paintings sell themselves.

If I am able to capture even a blink of her eye, then perhaps I too can grasp the magic that is Riva Yares.

Mother and son.

My daughter, Shelli.

XVII
MY DAUGHTER, SHELLI

My daughter, Shelli, is my beautiful treasure and my best friend. I feel almost like she and I are alone in the world called America.

I sent her to school in Israel when she was the impossible age of fifteen, because I wanted her to learn Hebrew and also to learn some values. In high school in Israel, they prepared her for war. She and her school friends had to carry guns and ammunition and climb the famous Masada Mountain. When she returned to Arizona after a year, she was a young adult.

While I was married to Clare, there were five boys in the house. Shelli fit into that situation (and others that came along) in the most gracious way. She always knows how to carry herself.

Shelli is a now lawyer in Arizona. She and her husband, Alex, were both prosecutors for the state. Eventually, they got married. Pregnant with triplets, Shelli went into labor on Labor Day and gave birth to two boys and a girl, who are eleven years old now.

At first, they lived by the current location of the gallery in the building we called the "doghouse," where I raised my own children as teenagers. We called it that because it didn't have any windows on the ground floor—only a doggie door for our dogs to use. Because the original occupant of the house was the Mormon bishop, the street was and is still called Bishop Lane.

Shelli sleeps with good dogs.

In the words of Shelli Poulos—

It was a typical Sunday afternoon when Sam, my biological father, came for his scheduled visit. He had a new dress for me and a Mr. Potato Head for my brother, Dennis. I was six years old, and my brother was ten.

Our father told us we were going on a little trip. We had no idea, nor did our mother, that we would be boarding a plane bound for Israel, thousands of miles away! When we arrived in what had been our native land, our dad dumped us at a children's camp. I later learned that he did this to spite my mother for divorcing him.

As a mother now myself, I cannot imagine what my mother must have felt when my brother and I did not return that evening. My mother, the fighter, the warrior that she is, never gave up the search. Once she learned of our whereabouts, she and her father, a resident of Israel, rescued us.

It was a scene I will never forget. My brother and I were in the camp swimming pool. The two of them drove up in an army jeep. Riva, clad in a swimsuit, jumped in the pool, and whisked us away.

Very often I think of what my mother endured during that horrific episode, and I shed many tears. I think of her as a single mother living in America—a foreign country to her—searching for what mattered to her the most, her children.

XVIII
FRANK LLOYD WRIGHT FOUNDATION

My friend, artist Lew Davis, had also been a good friend of Frank Lloyd Wright in the years before the great architect died in 1959. Lew introduced me to Mrs. Olgivanna Wright, who took a liking to me. Mrs. Wright was a Russian lady and even in old age was beautiful. She was a powerful woman and used her power. Frank Lloyd Wright had been very theatrical, and so was she. She was his last wife.

Taliesin West, Wright's winter home in North Scottsdale and headquarters of the Frank Lloyd Wright Foundation, operated a school for young architects. The student architects lived in tents in the desert, and after school they did various chores, such as cleaning and cooking. There were two requirements for being accepted into the foundation school: First, you had to have money; and, second, you had to play an instrument or sing or dance. Mrs. Wright was into music.

Every Saturday night at Taliesin West, there was a formal dinner and musical event, with all the men in tuxedos and all the women in long evening dresses. Mrs. Wright often invited me. She liked that I was exotic looking, an original among all the rich ladies who supported the foundation. I would wear very colorful clothes, like long silk embroidered dresses that I'd found in a Pakistani shop on Fifth Avenue.

The evenings began with cocktails served in Mrs. Wright's living room, where she was seated on a small stool. On each side of her sat a black Great Dane with a diamond collar—very beautiful creatures. I always thought that she seated herself on a low stool so people would have to bow when they greeted her. After all, she was the queen. After cocktails came a formal dinner, served by the young architects. Later the guests were escorted to the Taliesin West Theater for a musical or dance performance.

I was restless and didn't really have any direction to my life. When things weren't going well for me, I believed I could always escape to Taliesin and marry one of the architects. I was fascinated with the foundation and the people there. Ling Po, a wise man, was a gifted apprentice who had been with Mr. Wright from 1946. He was Chinese—very small, thin, and brilliant—the son of royalty. Mr. Wright had met his family in China, and Ling Po wanted to join Mr. Wright in Arizona. Ever since that time, Ling Po had done all of Mr. Wright's architectural renderings and participated in all aspects of Taliesin life. He eventually became a principal architect for the Taliesin

architectural firm. He was deeply interested in Buddhism and later in life joined a Buddhist monastery, spending his days in meditation, prayer, and reading the Sutra.

One day I was walking in the desert with Ling Po. As we walked in the hot, arid country that surrounded Taliesin West, I said to him, "I don't have peace of mind. How do I find it?" He answered, "For peace of mind, you have to give up your ambitions."

One of the young architects was a very handsome man named Keith Kennedy. Every day he would come to the Scottsdale gallery from the foundation, a forty-five-minute drive, in order to bring me a red rose, until a very jealous Douglas Webster (the man I was living with at the time) drove him away. Making love to Keith was wonderful. He was very well built, and he knew how to make love to me.

Around the same time, I had an affair with Kamal Amin, another architect at the foundation. He was an aristocratic Egyptian; I was an Israeli. His background and my Jewish heritage made him intriguing to me. It was the forbidden fruit. He looked like a young pharaoh and showered me with gifts. But there was one problem. He stuttered. We would go to a restaurant, I would order a glass of wine, and Kamal would order a whiskey sour. Wh-wh-whis--k-k-key sss-s-s-ou-r.

I said, "Can't you order something with only one syllable?"

He always wanted to make love under the stars. It was great, until he opened his mouth—and then it wasn't good.

Later on, at the urging of Mrs. Wright, Kamal married a very rich, rather fat lady, Mrs. Kaiser, and he stopped stuttering. He only stuttered around me.

Mrs. Wright also arranged the marriage of Mr. Wright's protégé, Wes Peters, to Svetlana Alliluyeva Stalin. At one of the Taliesin events, Svetlana and Wes were sitting directly in front of me. I couldn't believe that anyone even remotely associated with Joseph Stalin, much less his only daughter, could be sitting so close. When I was in Warsaw a few years ago, I was told that after World War II, Stalin ordered his military to level the city. It was rebuilt later from sixteenth-century plans. This, along with so much else, made me hate the name Stalin.

At that time, the Foundation architects were remodeling the Biltmore Hotel, a wonderful structure that Frank Lloyd Wright had been involved with in 1928. As a

result of my being close to the Foundation and having a gallery, I was asked to choose the art. I chose original Lew Davis paintings for the hotel restaurants and had prints made of the same pieces for the guest rooms.

Walking in Frank Lloyd Wright's steps was a great experience for me.

Los Angeles Gallery on La Cienega Blvd.

XIX
LIVING IN LOS ANGELES

In the early seventies, Phoenix and Scottsdale were changing. The city fathers had decided to flatten the barrio and relocate the Mexican laborers to a different part of town, where they would have running water. When they went, the color disappeared with them. The little Mexican cantinas closed, replaced by gringo restaurants, and new people moved into town.

I got a little bored and restless. On weekends I would visit friends in Los Angeles. One Sunday we were walking on La Cienega Bouvelard, L.A.'s gallery row, and I saw a space for rent. I signed a lease on the spot. I had decided to open a second gallery in L.A., and I packed up and moved there with my children.

Thinking back, I was eager to live in a place with more excitement. Los Angeles was a home of artists and had a variety of interesting galleries. The art scene was alive. I was also very interested in films and thought that I could step into the movie scene.

I found a great place to live on Sunset Plaza Drive in West Hollywood. It was a large building with very large apartments, where quite a few aspiring movie stars lived. The building had a big swimming pool, and the aspirants to moviedom would walk down with their phones, waiting for agents to call. Long before cell phones, there were phone plugs by the pool.

We lived on the third floor. One of the rooms was huge, with an east-facing wall that was all glass with a partial view of the Los Angeles skyline.

The woman living in the apartment next to mine was Joyce Selznick, niece of the great Hollywood producer David O. Selznick. She was a big fat lesbian, who would sit there with her apartment door open—on her couch, in her underwear, her big breasts spilling out. She lived with ten dachshunds. The apartment building was built around open balconies, L.A. style. Whenever we came up in the elevator, we had to walk by her door, and her dogs would come out onto the balcony and attack us. Joyce was a casting director and agent to the great stars. She'd discovered Tony Curtis and helped to launch the careers of George C. Scott, Candice Bergen, and Faye Dunaway. I saw her there with Rock Hudson, as well as with many other stars.

As I walked by one afternoon, she called out, "Come on in." She said, "I dare you to go dancing with me." I shocked her when I said, "I'll be happy to go dancing with you."

Glamour in the gallery.

So, Joyce and Riva went to a lesbian club to go dancing. I did not enjoy myself—dancing to an all-woman band with a big sweaty woman who smelled like a baboon—but I pretended to have a great time, which also shocked her. After that, our relationship improved. She no longer sent her dogs after me.

It seemed that every brilliant idea I had in Los Angeles didn't work out. First, I decided to name the gallery the "Riva Yares Gallery of Israeli Art." Working directly with the Israeli Ministry of Culture, I wanted to show what high-level, contemporary Israeli art really was. I was very patriotic about my home country.

I figured that there were many rich Jews in Los Angeles and that I would do very well indeed. The opening day came, the gallery looked beautiful, I looked beautiful, the Israeli Embassy sent out many invitations, and a lot of rich Jews attended, dressed to the nines. They came, they saw, and they didn't buy anything. The only two pieces I sold during the entire year of the gallery's existence were to my friend, the actor Nehemiah Persoff.

My first business venture didn't work out as I had hoped. My private life didn't work out either, starting from my first night out in L.A.

My friend Malvina Hoffman gave a party. She was a long-time Angeleno who lived in a very large Frank Lloyd Wright house down the hill from Marlon Brando. I was invited and I went. My first LA party. I met a man there who was quite interesting and good-looking. He told me he was a professor of Psychiatry at UCLA. We enjoyed each others' company there, and he suggested that we go for coffee. And me, a little immigrant from Israel and Arizona, I said, "Okay, I'll drive behind you." I followed him and followed him, over hills and valleys for maybe forty-five minutes. No coffee shops there. Then he stopped on a hill, very steep, near his house. I tried to park behind him, but the car kept slipping backward. He said he'd take care of it, and he did. So then I went with him up to his house. Three steps into the living room, he grabbed me and tried to kiss me passionately.

Riva: "What are you doing? I thought we were having coffee."

Professor of Psychiatry: "What do you think coffee is?"

He disappeared into the bedroom. I left and went back down to my car. Okay, here's trouble, major trouble. My car wouldn't start. I was panicking. I went back to the house to call a tow truck. It was two in the morning. At four in the morning the tow-truck driver finally arrived. And there I was, sitting between two big gorillas in the tow

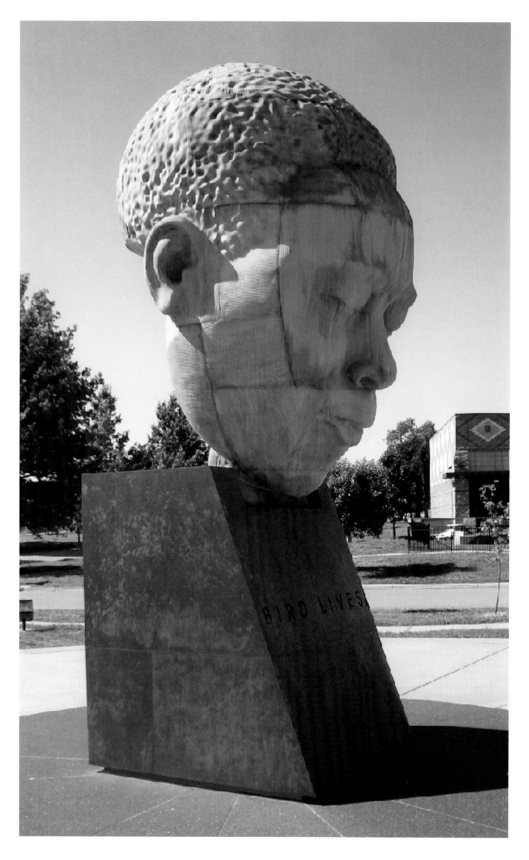

Robert Graham's Charlie Parker.

truck. They said they would drop the car at a garage on Melrose but that they wouldn't take me home. My body rigid with fear, I walked home alone at five in the morning from the garage to my house. I don't know how I got home, but I walked and ran the two miles as fast as I could.

The next morning I got a call from Malvina, who yelled at me, "How dare you take off with my boyfriend!" So she became my worst enemy.

I could not function as an art dealer in Los Angeles, which for me was a sea of lies. Someone would drive up in a Rolls-Royce, come in, say he was going to buy five pieces but didn't have his checkbook—and would never come back.

I got friendly with a Japanese art dealer on La Cienega, who gave me a one-sentence piece of advice: "Don't pay attention to him, he is a name-fucker." By this she meant someone who'd say he was related to the Rothschilds, or that he owned six Stellas—that was someone who didn't really have anything.

So, Los Angeles was not good to me. No business in the art world, no action in the romantic world. To put the final stamp on it, there was a major earthquake—electric lines blowing up, the floors shaking, the kids under the beds. I thought it was the end of the world. My first earthquake—and a sign to leave.

The next day, my kids and I said good-bye to Los Angeles. I went back to Arizona, chastened. I didn't even have a place to live.

One short bright star in my Los Angeles adventures was having a little fling with Milt Jackson.

I met him at a birthday party for his agent's daughter, who was a friend of my daughter, Shelli. Flip Wilson and many other show-business people were there that night. I was introduced to Milt Jackson. He wanted to see me again, and the agent called to arrange our date.

Milt was tall and handsome, a perfect gentleman. He was dressed in a beautiful suit when he came to get me. We went to the Lighthouse, a jazz citadel on the pier in Hermosa Beach.

At the time, I didn't know that Milt Jackson was so famous. When we walked into the club everybody stood up and clapped and, naïve me, I thought it was because

I was so pretty. I found out that he was part of the Modern Jazz Quartet and adored by everyone in the world of jazz.

I had breakfast with him at five in the morning and saw him a couple more times—a wonderful time with this beautiful man before he left for a concert tour.

Years and years later, I met Milt Jackson again in Kansas City. The sculptor Robert Graham was commissioned to create a thirty-foot head of jazz legend Charlie Parker. Graham and his wife, Angelica Huston, went to Kansas City for the dedication of the piece, and they asked me to be part of their entourage. All the great jazz musicians showed up to pay their respects. I walked in the parade with all those people. I was so elated, and over there, near the big head of Bird, I met Milt Jackson again. We talked about that time years before; he hugged me, I kissed him.

Six months later he died.

XX
MY GRANDFATHER APPEARS IN RYE, NEW YORK

Douglas Webster was twenty-nine when I met him. Having just come from Detroit, he came to the gallery, looking for a job, and insisted on seeing me. For some reason I was intrigued by him. I invited him to dinner at the little house where I lived so that he could tell me his story. He loved the food, and he came out with the old phase, "What are doing for the rest of your life?"

I found out that he had been an Olympic swimmer, an art major in school, and previously involved in the art business in Detroit. He had owned a gallery with another man. His partner, a minister, was killed one night, Mafia-style. That's what was in the Detroit papers. Douglas told me that he found him dead the next day and left for Arizona a day later.

The FBI came to question me. Apparently the minister had taken out a life-insurance policy in Douglas's name, even though he was married and had two children. That's why Douglas was a suspect. To this day, I don't know who killed the minister.

Douglas was a good-looking man. He was blond, with blue eyes and the body of a swimmer. He played the guitar quite well and wrote songs. The first time we went to bed, I asked him to leave before daylight. At the time I was quite self-conscious, and I didn't want him to see me first thing in the morning. He said, "But darling, it's cold outside, and I have a motorcycle."

He started to work at the gallery and was quite good at it, as he had a good voice, knew art, and wrote well. He moved slowly into my life, into the gallery, and eventually into my house. We lived together for a long time, and it was a good life. He was my big watchdog, looking out for me so that I could be creative and independent.

I wanted to see America. I rendezvoused with Douglas and his new white Corvette in New York City. We were going to drive from New York to Arizona, and the two-seater was fully loaded with his guitar and my clothes. That's how we went on the road.

Near the exit to Rye, New York, a policeman pulled us over. It was twilight. He walked over to the car and asked Douglas for his license and registration. We hadn't been speeding, and everything seemed to be okay, so the policeman told us we could go.

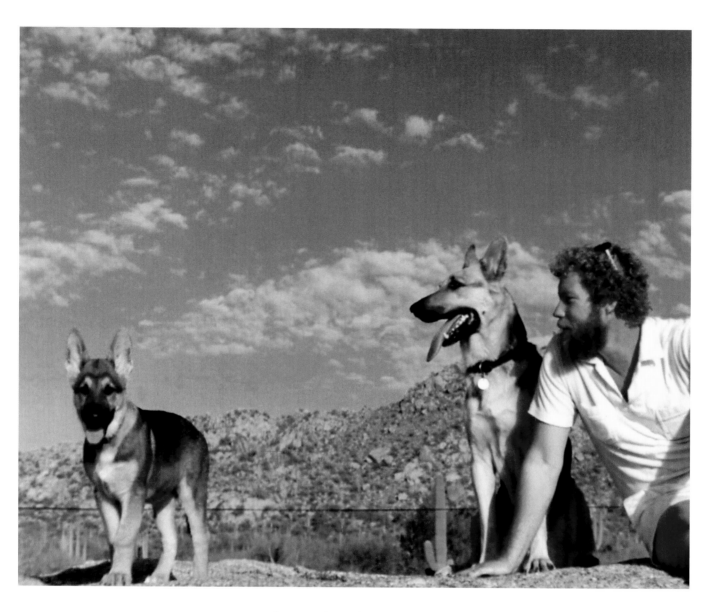

Douglas . . . three dogs in the desert.

Douglas tried to start the car but nothing happened. No matter what he did, it wouldn't start. I ran over to the policeman, who was still sitting there in his cruiser. I was quite upset. I told him he couldn't leave us there, in a brand-new sports car in the middle of nowhere—we needed help. I wouldn't let him go.

So Douglas and the policeman tried to start the car. Still it wouldn't start. I was frightened. The car was parked next to some dried-out trees and bushes, with no town in sight, and night was falling. All of a sudden, a very old Jewish man appeared. He had a long white beard, and a prayer shawl was draped over his shoulders. He resembled my grandfather. He brushed by me, not saying a word, then disappeared into the bushes and was gone. The policeman was so startled that all he could do was yell, "Who is that? Who is that? Where did he come from? Where did he go!"

I felt as though I were in a trance. I went over to Douglas and calmly said, "Give me the keys. The car will start now." The car started.

A moment later I began shaking from the experience. I remembered what my grandfather had said to me those many years ago in Poland, "Nothing will ever happen to you, my child."

We spent the night in the nearest motel, as I became quite ill from this amazing visitation. It was as real as anything could be. I had two witnesses.

Another dog, another desert.

XXI
RICHARD—NEW YORK

I went to visit my parents, taking Dennis and Shelli with me. I found that Israel hadn't changed, but I had, after living in America for almost seven years. Everything there was now strange. Dennis wouldn't leave the house because the Israeli kids would pull his hair and make fun of him. I felt I had nothing in common with these people with whom I'd spent the first twenty-five years of my life. They were arrogant and sarcastic. They had little patience and said exactly what was on their minds. In Israel, life was lived in the fast lane.

I decided to go on my own to Jerusalem, a city that I had always loved. The western wall of King Solomon's temple was still standing, now called Kotel Maaravi, the Wailing Wall. Jews and non-Jews from all over the world go there to pray, touch the wall, and put notes addressed to God in cracks between the stones.

I stayed in a monastery built by the side of the wall, which had been turned into a hostel. In the morning I got up, felt wonderful, and went down to breakfast, which was served at a long communal table. A group of Americans were there on their way to an archeological dig across the border. The man sitting across from me at breakfast had beautiful blue eyes and wavy, long white hair. I wanted to start a conversation with him but didn't know how, as I was quite shy then. I said to him, "I like your ring," although it was a very ordinary school ring. And he said, "I like you." His name was Richard. He said I must be an Israeli *sabra*; perhaps I could show him the country when he returned from his dig.

I told him I had two kids back in Tel Aviv with my parents. He said fine, he would pick us up when he returned. So he came to Tel Aviv to get us and we went on our big trip—showing Richard my country.

Richard always wore the same thing, even though it was clean: jeans, a blue work shirt, and zoris. During our trip he told me that he was very interested in longevity, and that he was going to put together a book on the subject. I said I knew about the Jewish Yemenite tribes who lived very long lives and never had heart disease. He offered to hire me to do research on the matter, and I accepted.

We went to the Red Sea and stayed in a hotel. I didn't know much about him, except that he was kind, intelligent, good-looking, and my kids liked him. I thought he was very cool.

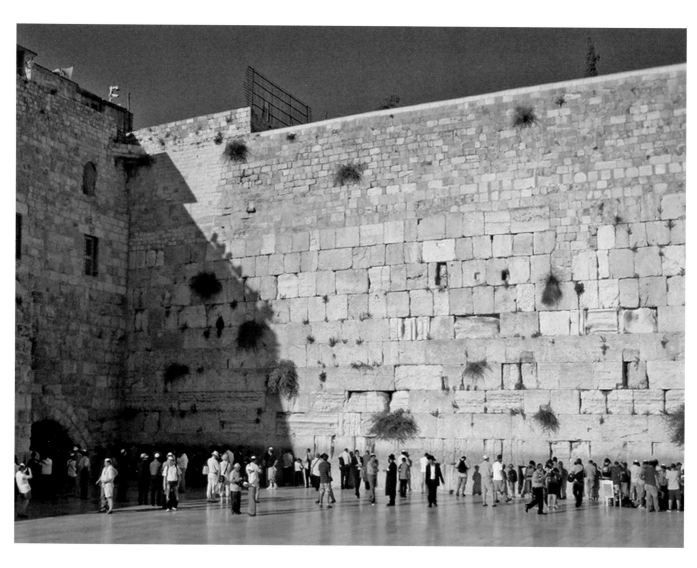

Kotel Maaravi, the Wailing Wall. Photo © Israeli-frontline.com, November 24, 2010.

My kids and I stayed in one room; he stayed in the room next door. About ten o'clock that night there was a knock on the door. I said uh-oh. It was Richard, asking me to lend him a hundred dollars. I thought he must be one of those guys who would take my money and run. He said he'd give it back to me when I visited him in New York.

When we returned to Tel Aviv, I decided to go back to America, as Israel no longer suited my temperament. Back in Arizona I got a phone call from Richard. He said, "Why don't you come to New York and we'll discuss the book on longevity." He sent me a plane ticket and I went. I liked him and hoped that something would come of the relationship.

Richard said he'd meet me at the airport, but when I arrived, no Richard. Instead, there was a young man holding a sign with my name. He said, "Mr. Lapote is busy and I'm his driver." I thought, okay, a big black limo. He drove me to Richard's house, which turned out to be a brownstone on the east side of Manhattan, around the corner from the Whitney Museum.

Richard lived on the fourth floor, with no elevator. I said to myself, he must really be poor and I will never see my hundred dollars again. The young driver carried my suitcase up the stairs and opened the door to Richard's apartment. I was shocked. It was absolutely beautiful—great art, exquisite surroundings. I was impressed.

When the driver left, I was alone in this strange apartment. The phone rang and I answered it. It was Richard's secretary, telling me that Richard would be a little late but that I should help myself to the hors-d'oeuvres and champagne in the fridge.

Finally he arrived. We had a great week in New York, visiting museums and galleries. He bought me an Afghani coat from a street vender, as I was cold. We went to the theater and wonderful restaurants, and I realized that he must be a wealthy man with very educated tastes. We discussed the longevity book, and he wrote me a check as a down payment for my research and writing.

The only problem was that our sex life was not very good. He was very self-absorbed and an LSD man. He would get up in the morning, screaming that his thumb was five feet long and he wanted me to take him to the doctor, or he'd find a pimple on his shoulder and think that he was dying. I knew this would not become a romance

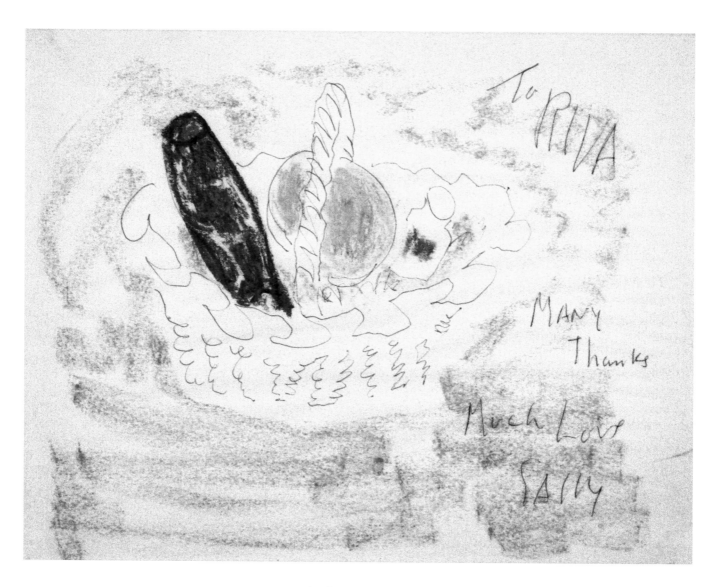

The "arrangement."

when I bought some flowers, put them in vases, and they died the same day. If the flowers couldn't exist in this environment, then certainly the love affair couldn't. Instead, Richard became my New York friend. Every time I went there I would see him, have dinner with him, and maybe sleep with him.

At one of our intimate dinners, Richard said, "Riva, I would like very much to have a committed relationship with you." And Riva said, "It cannot happen, you're not romantic enough for me. You never send me flowers." The next morning, ten minutes before I had to leave for the airport, I opened my hotel-room door to find a huge arrangement of flowers, chocolates, and delicacies. What was I going to do with all this in the next ten minutes? I thought of Sally Avery, whom I'd recently met and liked very much. I called the bellboy, gave him Sally's address, and sent Richard's enormous bouquet to my new friend.

At that time in my life, I was living with my friend Douglas Webster. One time when we made a trip to New York together, Richard asked me to have dinner with him.

The next day I was going to Paris with Douglas. Richard was very curious about where I was staying. He was leaving the next day for Timbuktu. When I arrived at the hotel, I went to sleep, and after ten minutes got a call from downstairs. It was Richard, who'd followed me to Paris. He asked if he could come up to my room, and I said, "No, I have a man in my bed. We will come down, meet you, and have breakfast together." Well, we had breakfast, and I guess he and Douglas exchanged drugs. Games men play.

Just before we flew to Italy, I told Douglas that the Italians were very strict about drugs and that he should dump his marijuana into the toilet. Obviously, he didn't.

When we arrived in Italy, at the airport were a lot of young soldiers with guns. They asked Douglas if he and I we traveling together. He said yes.

The young inspector told him to open his attaché case. Inside were forty film canisters. The inspector pointed to one of them and said, "Open it." This was the only one out of all forty that contained marijuana. They arrested us, took our passports and the marijuana, and went through everything in my suitcase.

I'd just seen the movie *Midnight Express*, so in my imagination I was already in jail, figuring how to get out. I had an Israeli passport somewhere, and I thought that I'd just leave Douglas to rot in prison.

With Kenji Umeda, Carrara, Italy.

He was this big hero, a former Olympic champion swimmer, who was shaking in his boots. I coped by pretending that all this was just a movie, not real, and I sat up there on a table, being cool. After five hours they let us go. They even gave us back the marijuana, as Italian law specified that you could carry enough for your own use.

After this international episode, we left the airport and took a train to Carrara to see the sculptor Kenji.

To this day, I'm still angry at Douglas. If not for his drug addiction, we'd probably still be together.

A Yemenite husband and his four wives.

XXII
THE FIFTH WIFE

The Yemenite Jews are a tribe of exotic people who lived in Yemen, a small Arab country on the Red Sea. Their history goes back to the fourth century. When Israel became a state in 1948, the Yemenite king allowed the Jews to move to Israel, where they continued to follow their very special way of life. They believed that the combination of foods they ate protected them from disease, and they followed their dietary tradition religiously. The old people were very vital, both in body and spirit. They were happy and led very vigorous lives. They lived long and never suffered from any of the so-called diseases of civilization.

When I did my research work for Richard's book on longevity, I went to live with a Yemenite family in Israel. I liked them and found them easy to live with. I ate their food, helped prepare the meals, listened to their stories, and learned about their way of life.

They took me into their circle and opened up the secrets of their traditional eating habits and folk-medicine cures. In fact, the Yemenites considered me to be one of their own. Even when I told them I was not one of them, they would not believe me. One old Yemenite woman looked at me and said, "If she is not Yemenite, I'm ready to cut off my right arm." So I had no choice—I was a Yemenite, and it made me proud. This was not new to me. Even as a little girl I was considered to be Yemenite because of the way I looked. Perhaps in spirit I am.

After two months of living with the family, I said bye-bye, I have to go back to America. The husband, ninety years old, grabbed me and said, "Take me with you to America."

I said, "But you have four wives!"

He said, "You will be my fifth wife."

In the clouds by the Silver Cloud.

XXIII
MY CHAUFFEUR, VICTOR

Douglas and I went to England on business. While walking in the streets of Brighton, I saw a most beautiful Silver Cloud Rolls-Royce. It was a 1963 model, the last year that it was made, a white beauty with a black interior. I wanted that car. I desired that car. I had to have that car. It was everything I needed in my life at that moment. The 1963 Rolls-Royce Silver Cloud had to be mine.

I bought the Rolls-Royce and had it shipped to Long Beach, California. It took two months to get there. I picked it up, drove it to Arizona, and felt like the queen of the world. It was a difficult car to drive, as the steering wheel was on the right-hand side.

Now that I had a Rolls-Royce, I had to have a chauffeur. I thought my best bet would be to go to an agency. I explained that I needed a man who could deal with a Rolls-Royce but who could also do other chores. I couldn't afford a maid, a cook, and a chauffeur, as they had in the "right" households. I needed a chauffeur who would be all those things.

The woman at the agency said she had just the right person for me. The next day, the agency lady brought the man for an interview. I was very impressed. He had just the right look, being six-foot-two and slender, with white hair pulled back in a ponytail. He said he was forty-six.

His name was Victor. He'd brought me letters of reference from his former employers in Chicago and New Mexico. I asked the agency woman if he had a police record. Her answer was, "The law in Arizona doesn't allow us to reveal anything like that," which was not true. I hired him anyway, and he lived in the guesthouse and took care of all my needs. Speaking with a British accent, he called me "madam" (which I loved), and was very happy to do all the chores that I assigned to him.

Victor had one request: I had to buy him a uniform to wear when he drove the Rolls-Royce. I asked, "What kind of uniform do you wish to have?"

His answer was, "A grey Armani suit." Victor and I went shopping for the grey Armani suit. It looked absolutely fabulous on him.

Victor wrote poetry, painted, and spoke well about literature. He was quite a mystery to me. When he attended to the chores of the household, he would wear

bell-bottom pants, a T-shirt, and a headband. When he went to the airport to pick up clients or artists, he would wear the Armani suit. And when he served dinner, he wore a butler's vest and perfectly tailored trousers. I had no idea where he got those. I made up my own scenario. Maybe Victor was serving time in the late sixties, as all his clothes were from that period. Maybe he taught himself to cook in prison.

<p style="text-align:center">***</p>

The artist Esteban Vicente came from New York for a few days, and I arranged to have a dinner party for him—a sit-down dinner for twelve. We were serving duck, and Victor was the chef.

In the morning, he asked, "Madam, could I have money to buy twelve ducks?" I said, "Victor, why do we need twelve ducks?" And he said, "Madam, there is only one small part of the duck that is appropriate to serve. That's why I need twelve ducks. The rest is trash." Well, I had no choice. The chef wanted twelve ducks for twelve people. The dinner was spectacular, and so was Victor.

Another thing Victor did that was a dream come true for me—every night he put a rose and a glass of Cognac next to my bed. And it was quite the sight, also, to see him folding my underwear. He did it all, until things started to unravel.

One night Victor drove me to a party in his Armani suit. He turned around, opened his jacket, and said to me, "Do you like this, Madam?" I almost fell out of the car, because inside his jacket was a forty-four magnum in a beautiful holster. I said, in a frightened voice, "Why do you need this, Victor?" He said, "To protect you, Madam."

Also, I had gradually discovered that Victor was drinking on the job. Beginning first thing in the morning, he would drink Coca-Cola and vodka, and I finally figured out that he was drinking all day long.

One evening he picked me up from the airport, completely drunk. The car was weaving the whole way. I got home all right, but the Rolls-Royce had a few nicks. The next morning, I told Victor that I wanted to talk to him. Here were just the two of us in my penthouse, Victor looking very distinguished. And I said, "Victor, I'm giving you seven minutes to clear out of here, and I don't want to see you ever again."

He said: "But, Madam, why?"

I said: "Because you drink."

He said: "Madam, why didn't you tell me?"

I said: "Because you know."

In seven minutes, Victor and all his belongings were gone. I never heard from him again.

That was the end of Riva's beautiful dream of a chauffeur and a white Rolls-Royce.

The magic of Arizona.

Jonas Salk was my God when my children were young.

XXIV
JONAS SALK

In the gallery I showed the work of Francoise Gilot. She had been Picasso's mistress and the mother of Paloma and Claude. At that time she was married to Jonas Salk, who was heading the Salk Institute in La Jolla.

They came to visit in Scottsdale then invited me to come for a weekend to their house in La Jolla. They were planning a party for Simon Wiesenthal, famous as a Nazi hunter and for his *Life Magazine* photographs. It's amazing to me how the world goes around and around. This man had taken a picture of me in Israel with a group of schoolchildren. He picked me out from the crowd of children, which he remembered when he saw me.

I stayed in their La Jolla house. In the morning I was sitting in the kitchen, and Jonas Salk, in his pajamas, was cooking breakfast for me. I think that was one of the greatest moments of my life.

While my children were babies in Israel, Jonas Salk discovered the polio vaccine. In my eyes, he was God. And now I'm sitting in his kitchen, and he's cooking breakfast for *me*.

We developed a great relationship. I just adored him. He was a Renaissance man—science, art, literature—and a beautiful human being. He took me to Palm Springs and introduced me to his brother, who was a veterinarian. Dr. Salk wanted him to meet this Israeli girl, Riva.

I love you, Jonas Salk.

XV
BABY THAYER
and
THE NIGHT OF THE FUR COAT

Baby Thayer belongs to early Arizona. Her father was a multi-millionaire in Chicago, and to escape the rules of Chicago society, she took off for Arizona.

Baby Thayer bought herself an Eva Peron yellow Rolls-Royce convertible, with all the handles done in gold. She was very tall and very beautiful, although she had bird's legs and a little puffed tummy, like people who drink a lot. She was an eccentric lady, a good friend of Lew and Matilda Davis, and an incredible art collector. And she threw grand parties.

Baby Thayer would often travel abroad, especially to Italy, where she had a young boyfriend, a photographer named Luciano, who was in his early twenties. When she traveled, in one hand she would carry a pillowcase filled with her clothes. Whatever would fit in the pillowcase, that was what she would take with her for the trip. In the other hand she would carry what looked like an attaché case. It was actually a portable bar.

Once a year, Baby Thayer took all the children in the neighborhood, including mine, for a ride in the Eva Peron Rolls-Royce up and down Scottsdale Road.

At that time she was engaged to the world-famous sculptor Isamo Noguchi. She was interviewed for a Chicago paper and announced that she was going to marry the sculptor. Noguchi was very angry that she had made it public, and he broke off the engagement.

Then she went on a cruise, fell in love with the ship's pianist, and married him. Braggiatti was his name, and she had a son with him. Mr. Braggiatti showed up only for Christmas.

There will never be another Baby Thayer. I miss her.

<p style="text-align:center">***</p>

Before we went to America, Sam persuaded me to buy a fur coat, as that was how it was done in America. I said, "I don't want to wear a fur coat. I don't want a dead animal on my body!"

In America the fur coat hung in the closet. I wouldn't wear it.

I missed my father, and I came up with an idea. I would sell the fur coat, buy a plane ticket to America, and send it to my father.

I took the coat to Baby Thayer.

I asked her, "Would you like to buy a fur coat for a thousand dollars?" I laid the coat in front of her.

Baby Thayer said, "It's a great idea. I'll give it to my daughter-in-law, Sarah, for Christmas." She gave me the thousand dollars, I bought the plane ticket, and my father came to visit.

About ten years after this incident, I was at a party and saw Sarah, who, by that time, was a well-known appellate-court judge. I went into the bedroom to throw my coat on the bed and saw my initials winking at me from a black fur coat lying there next to my wool one. This was the fur coat that had been mine at one time and that Sarah had received from her mother-in-law.

To this day, Sarah doesn't know that her fur coat once belonged to me.

Jean-Michel, a different breed of dog.

done, like filling a bathtub with red rose petals. He bought me beautiful clothes and hats. But then there was the other side.

We would see each other for ten days at a time. Longer than that, and it was trouble. When we were driving together, I would say, "Make a right turn," and he would make a left. If I ordered two Jack Daniels, he would take the second one away from me, saying, "You know it's not good for you." He would borrow my car to go to the store and not come back for two days.

Men didn't like him—he was always taking chances and causing trouble every place we went. He was very much an elitist, very French, and so good-looking. To me he was my gypsy.

One time when we were traveling on a train, I saw a billboard for the designer Gaultier. The Gaultier model looked fabulous, dressed in tight jeans and a striped sailor's jersey. I said to Jean Michel, "I think I'm falling in love with this man on the billboard," and he said to me, "I'll be right back." And after ten minutes he came back, dressed just like the Gaultier model. We had no luggage with us, so I said to him, "Where did you get those clothes?" He raised his finger to his lips and whispered, "Shhhhhh."

I was convinced that he was totally psychotic. He once said to me, "If you ever leave me, I will kill you." There were times when he made me so angry that I thought I would have a stroke. I felt that I was slowly becoming more like him, and I didn't like it. I began to play the same sort of mental games with him that he was playing with me. I loved him, but I didn't like him.

On good days, he would say to me, "I love three things. I love you, I love Corsica, and I love music."

Jean Michel was like a bad movie. You might enjoy it while you're watching it, but when you walk out, there's nothing left.

∗∗∗

As my relationship with Jean Michel grew stronger, he took me to his second love, Corsica. He loved the island and told people it was his native country, which wasn't true. Perhaps he compared himself to Napoleon, who was born there. Jean Michel spent a lot of time on the island, filming Dorothy Carrington. She was a fascinating English lady who came to Corsica years and years ago, and Jean Michel was intrigued with her.

Corsica, my love.

An archeologist and an anthropologist, she had discovered many things in Corsica, many artifacts important to Corsica's history. She became a hero to the people.

Jean Michel wanted me to meet her. It was very important to him. At that time she was around eighty and very elegant. She treated Jean Michel as a slave, ordering him around to make tea and fetch things for her. She treated me like I was royalty.

We stayed in a very primitive hotel. Next door was a partly finished apartment building owned by a German. One night during our stay, at three in the morning, a bomb went off, destroying the building. The Corsicans didn't want Germans owning any part of their island. It seemed like there was a bomb explosion in nearly every city I visited.

In Corsican culture, the dead live better than the living. They get the best real estate in town, with an ocean view. It's almost like a city—with streetlights, gardens, and little houses for their ashes, made from marble and granite. These are the most beautiful buildings in the city.

One night I had a crazy idea. I told Jean Michel, "Let's go to the cemetery, run naked at midnight, and see what will happen." He said, "No, absolutely not." He explained that if some crazy person was hiding here, he could run away but they'd be able to catch me. It was just a crazy idea. I didn't really want to do it, but I wanted to see his reaction. At four in the morning, he woke me up, saying, "Let's do it." "Well," I said, "I don't feel like it now."

We went all around Corsica—for me to discover the island, and for him to visit old haunts. It was a very strange place, very raw and rough, as were the people. We traveled from one end to the other, from Bonifacio to Cap Corse. He told me he'd take me to the top of the world, where the gods lived. When we got there it indeed felt like the top of the world, very close to the clouds. Instead of gods, I encountered a lot of goats.

We went to some fabulous family restaurants built out of stone that served wonderful food, a mixture of Italian and French—no menu, every table getting the same courses, everybody very happy. The food was fresh and local. The vegetables were from the garden, the cheese from the goats in the yard.

Corsica was full of old towers standing near the Mediterranean, built to protect the towns. It seemed that now they were all abandoned. We decided that we would buy a tower and live there happily forever after.

The whole time traveling in Corsica I felt I was sitting on a time bomb, so I was anxious to leave. I said to him, "Yes, I'm going to live with you in Corsica," but I had

My prison.

the feeling that if we bought a tower and lived there, after a few days he would kill me and throw my remains into the ocean. After all, I came from the Mediterranean, and I would go back there if Jean Michel killed me.

We went back and forth to Corsica a few times. One of these times, he said to me, "You must go to Corsica by ferry, to arrive very early in the morning and see it just when the sun comes up." Well, the ferry was full of chickens and goats and people and children and their food. It was probably a holiday, and a lot of Corsicans who lived in France were going home to visit their families.

He got a room for us to sleep in during the twelve-hour journey. It was next to the engine room and one of the most disgusting places I have ever stayed in—the noise of the engine, the smell of oil, and two little cots. Finally I fell asleep, and some time after that there was a loud knock on the door. It was one of the ferry workers. He informed us, "The ferry docked a long time ago, and you are the only ones left on the boat." I had not seen the sun coming up over Corsica. As always, Jean Michel's timing was off.

I did not fall in love with the granite island. Corsica is for the Corsicans.

I love the music of Maurice Ravel. When I spent time in Paris, Jean Michel took me to the village outside of Paris where Ravel had lived. The old housekeeper kept the house in excellent shape. Jean Michel charmed her and she let us in. And there I was, in Ravel's house.

He'd been a small man, and everything in the house was small. The rooms, the paintings, and the objects d'art—all were small. When I went into his music room, I touched the piano where he had played and composed. I felt as though I'd been taken back to Ravel's era.

The old housekeeper touched my arm and brought me back to reality. She said, "Go ahead, play Ravel's piano." I don't know how to play the piano, but that day I did play Ravel's piano.

Many years later, in my house in Santa Fe, the great conductor and pianist Joe Illick played Ravel for me.

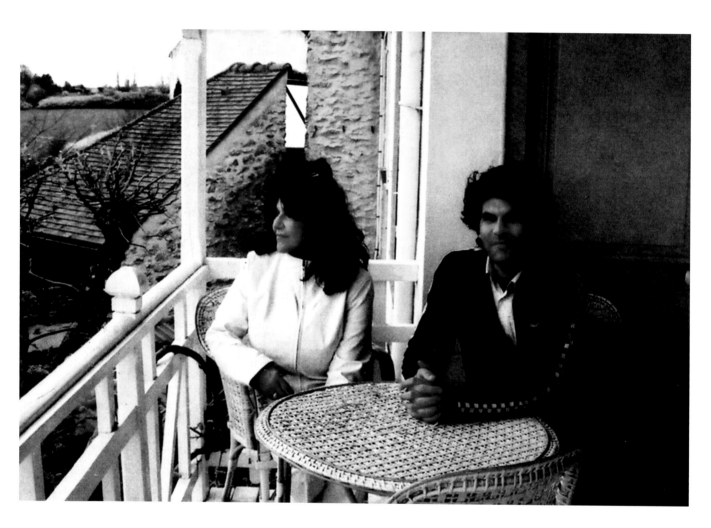

Ravel's balcony, outside of Paris.

I always admired Marguerite Duras and strongly related to her, although I didn't have her talent, and I wasn't an alcoholic. I related to her relationships with both gay and straight young men. During World War II she had fought with the partisans against the Germans. I was younger, and I rebelled later.

Duras was one of the most important literary figures in France. She is best known in the United States for her brilliant film *Hiroshima, Mon Amour*.

One evening, Duras gave some readings of her work at one of the French universities. A student, a gay young man by the name of Andreas, was so fascinated by her writing that he came knocking on her door one night. He wanted to spend the night, just to be with her, but she wouldn't let him in. He stayed outside until the morning. Finally she agreed to talk to him, and he stayed and stayed.

Andreas helped her a great deal. She was unable to type because of her arthritis, so he did all her typing. She had no money. She drank cheap wine and smoked. There were times when her legs wouldn't function and she was in a wheelchair, but she wouldn't give up the alcohol or the cigarettes.

Andreas was very devoted to her, but he would disappear for several days and not tell her where he was going. It drove her nuts. When I lived with Jean Michel it was the same—I was as angry as she was.

Her writings, her film scripts, her style of life—all were fascinating to me. I thought about making a film called *Marguerite Duras and Me*. I was so intrigued by her that I went to the village where she'd lived. I even wanted to buy her house, and maybe become her.

Marguerite Duras was born 1914 in Gia-Dinh, near Saigon. She died in 1996 in Paris, at the age of eighty-one.

My picture of Cuba.

XXVII
CUBA

I went to Cuba for the seventh Havana Biennial in 2001. The airport was filled with planes from all over the world, bringing in international museum curators and dealers. The biennial was very interesting. The theme was "communication," which a number of the artists interpreted as migration or escape. Cuban artists were obviously aware of what was happening in the American art world. The biennial included a lot installation, video, and conceptual art, similar to that in the United States. Nothing was really new except the real Cuban art, which depicted the situation in the county at the time. We went to visit many artists who were under house arrest for creating anti-government work.

I was very affected by the political situation and the poverty. Grocery stores would have only two or three cans on each shelf. People stood in line to pick up their rations—one tube of toothpaste and one bar of soap per family per month. Shoes and clothing were very, very expensive.

I talked to a lobsterman by the ocean. He told me that he had to give all his catch to the government, and if he sold a lobster to an individual, he would go to jail.

The new generation of Cubans did not understand why they were fighting. Why did they have sheets of plastic on car windows rather than glass?

I found the poverty there very disturbing. Even the dogs looked poor, walking in the streets in packs. I wanted to do something. I had travelers' checks, but only American dollars were accepted in the country. I took all the cash I had and bought sneakers in different sizes, then I hired a car and driver and drove around Havana, stopping whenever I saw a kid without shoes and handing him a pair of sneakers. I saw a barefoot prostitute in a doorway and gave her a pair of shoes. When I was asked, "Why sneakers?" I said, "If your feet are warm you can think! And if you are wearing sneakers you can run away."

Cuba to me was shoes, shoes, shoes.

I recall arriving at our hotel late at night. We tipped the Cuban tour guide and he gave us the Castro suite. It was the penthouse and very opulent—where Churchill and other great people had stayed—with a huge balcony, where guards had once been stationed. It was impressive and frightening at the same time.

Adios Cuba!

What remains of a country of color.

XXIX
E. L. DOCTOROW: I AM A FILMMAKER

"Everything tells me that I am about to make a wrong decision, but making mistakes is just part of life. What does the world want of me? Does it want me to take no risks, to go back where I came from because I didn't have the courage to say 'yes' to life?"

—Paulo Coelho

In my youth, reading books was my escape from loneliness. E.L. Doctorow has always been one of my favorite authors. One time he was invited by Arizona State University to give a reading at the Scottsdale Center for the Arts auditorium. I went with my friend, Edith, and we sat in the front row. He had just published a book of five short stories, called *Sweet Land Stories*. That evening he read a story called "Jolene."

I was fascinated by this man—he was tall, with a beard and very soft eyes, and his voice was so calming and beautiful. When he began to read, I closed my eyes to concentrate, just as I do at concerts. When he finished reading, I opened my eyes, turned to Edith, and said, "I'm going to make a movie called *Jolene*."

I wrote to Doctorow in New York. I said that I wanted to make a film of his beautiful story "Jolene," and hoped to meet with him. Several weeks later, I arrived in New York to see Christo's piece "The Gates" in Central Park. I went with my friend Kris, a very special person, a doctor who devotes his life to the homeless.

The day after I arrived, at nine in the morning, there was a phone call from Mr. Doctorow's secretary. She said he would see me at two that afternoon at the Pierre Hotel, where I was staying. I was so happy that I screamed so loudly that everyone on my floor opened their doors.

Being quite nervous about the meeting, I dressed very elegantly and ordered a drink to get up my courage. The waiter left, and my new god, E.L. Doctorow, arrived. We had a very interesting time. I told him that I'd never made a movie before, but that I must—must! —make this film, and that I'd devote all of myself to the making of it.

Maybe he liked me, maybe he liked what I told him of my life, but he let me have the rights to make *Jolene*.

I made the film *Jolene* in 2007.

With best-selling author, E.L. Doctorow . . . a new chapter.

I love literature, I love art, and I love music. I'd been involved with all three in my life but had never before combined them together.

Cinema was always very important to me. I had always wanted to make a film, but the timing had never been right. When E.L. Doctorow gave me the film rights to "Jolene," I decided to go ahead.

It was much harder than I expected it to be. I hadn't realized how much work is involved in making a film. To me, it's almost the ultimate art form, as there are at least a hundred people working on one project—with all their sweat, blood, and tears.

First I hired the director Paul Mazursky. At that time in his life he was very eager to make a film by Doctorow. He liked the story. When we celebrated the beginning of work on the film, I told him I would be his shadow, that I would be there every single day. I felt it was my responsibility. Mazursky did not like that idea. He told me in a friendly way, "You are not going to be there very day. You can come to the premier." So it was bye-bye to Paul Mazursky.

I hired a new director, Dan Ireland, whose films I liked, and we started to work on *Jolene*. I was present on the set every morning. My son, Dennis Yares, wrote the script. Doctorow liked it, and gave us the go-ahead.

I explained to the cinematographer that I would like every shot to be like a painting. The film would be visually beautiful, even though the story was quite sad.

Before I began making the film, I had purchased a large painting by Balthus. It is a typical Balthus—a very young girl with red hair, lying naked on a bed, with a mandolin. When it came to casting the movie, I wanted to find an actor for the role of Jolene who looked like the Balthus girl. We found her in Jessica Chastain, an amazing duplicate of the painting. At the time, she was on stage with Al Pacino in Los Angeles, playing Salome. She was perfect. The story called for her to play Jolene from the ages of fifteen to twenty-five, which she did beautifully. Every other major actor in the film—Chazz Palminteri, Rupert Friend, Dermot Mulroney, Teresa Russell, Denise Richards, Michael Vartan, and Frances Fisher—came to the set for only a week, but she was on screen for the whole movie.

Chazz Palminteri played Sal, a Mafia guy who was an art collector. We hung the Balthus painting in Sal's Las Vegas penthouse. In the film, Sal tells Jolene that she looks like the girl in the Balthus, his favorite painting.

My movie, released theatrically on October 29, 2010.

We brought original paintings and sculpture by Milton Avery, Hans Hoffman, Manuel Neri, Estaban Vicente, Yves Klein, and Fletcher Benton to the Las Vegas set of Sal's penthouse. The pieces were extremely valuable, and we weren't able to get insurance to cover them for the filming, so crew members slept under the paintings each night. In the film, the character of Jolene was an amateur artist, and all her drawings were actually done by the painter Turner Davis.

When we showed Doctorow the film, he said that he liked it better than any other film made of his work.

I named my film company Next Turn Productions. *Jolene* was my first film, and it showed at the Cannes Film Festival to very good reviews.

Now I am a filmmaker.

Making the film *Jolene* changed my life. It wasn't all good, but it was always surprising. I feel that good paintings should do the same.

The Art Dealer.
(painting: Gene Davis, Hot Susan, *1965.)*

XXX
RIVA YARES: ART DEALER

My dealings with artists and collectors are very intuitive. One cannot not go to school to learn how to be an art dealer. I never worked in a gallery or any other art institution. Growing up with paintings and going to art school in Jerusalem were my education. All this led me to have great respect for art. I would go anywhere in the world to get an artist I admired, and I would stay as long as it took to get his good work.

I really wanted the work of Anselm Kiefer, so I traveled deep into the Black Forest in Germany. His studio looked like a concentration camp. He greeted me and was very curious about me and my life. I didn't want to say much about my life—I wanted his paintings. I didn't have the money to buy them and wanted instead for him to consign a few works to me. It was the beginning of his career, and he was really hot. He kept me there for a long time. He knew I was Jewish and he had the German guilt on his shoulders. He kept me so long that I missed my flight. I think he did it on purpose. I ended up with nothing. It was not a good experience. Now he is quite rich and lives in Paris.

Sometimes getting the work is successful, and sometimes it isn't. You learn to accept the bad with the good. The wonderful artist Sam Francis was the antithesis of Anselm Kiefer. When I went to his studio in Los Angeles, I told him that I loved his work but at that point I had no money to buy it. He looked at me and said, "Take whatever you want, and when you sell it, you can pay me."

When I sell a piece, I always pay the artist immediately. If you have a gallery, you have to pay your bills and pay the artist. I am always on the side of the artist.

Artists, if they don't know you, often will try to get rid of their minor paintings and hide the great ones. I refuse to go along with that; I want the best. Some artists play a mental game with me to see how good a dealer I am. This is not easy but it seems to be a necessary ritual.

Dressing right is important. I never dress in business clothes, as most art dealers do. When I am going to meet an artist, I dress in the spirit of their paintings.

Sometimes I have to entertain artists, and sometimes I have to entertain collectors. One thing I learned to never do was entertain them together under one roof. One time, a Los Angeles couple bought a very large, very expensive painting from

Riva with Christo.

an Esteban Vicente exhibition in my Scottsdale gallery. They wanted to have dinner with the artist, so we all went out together. At dinner, the woman asked Vicente, "How do you paint?" Vicente, who was a Spaniard and very hot-blooded, said, pointing his finger at her, "*You* are stupid." The next day the collectors called me to cancel the sale.

There are times when a dealer has to travel with artists, as they all want a good-looking entourage with them. I traveled with Christo to Europe when he did an installation in Switzerland. That's part of a dealer's job. There were many collectors with him, and so many major parties. In Europe, great artists are treated like gods.

In the 1940s, one very important dealer in New York, who had the major contemporary art gallery in America at that time, was very rich and very homely. If an artist wanted to be in her gallery, he had to sleep with her. I did not take that road. I took my job as an art dealer very seriously. Sales were important to me, as I had two babies to feed. I never wanted to risk losing the respect of an artist or collector. An art critic once wrote of me, I was "chic, discreet, and deadly serious." These are very important qualities for a dealer.

Collectors are an interesting, varied, and sometimes strange breed. Most collectors don't want their purchases and the prices paid advertised. They want that kept confidential. Collectors will sometimes lead you to believe that they are buying something when they are not. A dealer has to have an extra sense about who is serious and who is just taking up one's time.

There are the collectors who come in, give you the impression they are going to buy a painting, lead you on as though playing a game, but then leave empty-handed. This takes a great deal of your energy, as a dealer always has to be polite and engaging. Being a dealer is very hard work and not glamorous, even though the dealer has to play the glamour queen.

I have a rule: If men wear good shoes, they have money to buy a painting. With women, it is the handbag. If she has a good bag, they have the money to buy. If a man likes his wife, she'll get the painting she wants; if not, she's not getting it. Women usually don't buy art unless the man okays it. Single women rarely buy art, even if they have the money. Single men don't buy art.

And it helps to have an accent, as I have. Collectors think you must be intelligent.

Lew Davis, the Dean.

XXXI
LEW DAVIS
and
LAKE JACK DANIELS

"...and Ronda with the old windows of the houses, the eyes which spy out hidden behind the latticework so that their lover might kiss the iron bars and the taverns with half-closed doors in the night..."

—James Joyce, *Ulysses*

In his time, Lew Davis was probably the most famous contemporary painter in the Southwest. He was born in Jerome, Arizona, in 1910, when it was a copper-mining boomtown. By 1953, when the mines closed, Jerome became a ghost town.

Even as a kid, Lew Davis was a very talented painter, and at the age of sixteen, he got a scholarship to the National Academy of Art in New York. Not having any money, he hitchhiked to the east. He was afraid to tell people that he was a painter. He thought they would think he was a sissy and not give him a ride, so he would tell them that he was a house painter.

After spending a few years in New York, being very successful and getting many awards, he decided to go back home to Arizona. The desert was in his blood.

He returned to Arizona and met Matilda, a very sophisticated and pretty young lady from Chicago, who made ceramics. Lew and Matilda got married and eventually formed an art colony and school in Scottsdale, where the rich women who were his patrons would come for art lessons.

In my lonely hours, I would go to the Phoenix Art Museum, as the only relatives I had were the paintings. I fell in love with Lew's paintings, and I asked the museum people about him and how I could meet with him, as I wished to show his work in my gallery.

I was told that he lived in the middle of the desert and received guests only on Sunday afternoons. Stubborn as I was, I went to see him on a Thursday. I didn't want to be one of the crowd paying homage to the great man, and I thought maybe he would pay more attention to me if I were there alone. For myself, I just wanted to be there with him. I had this little English sports car that was very hard to drive on the dirt

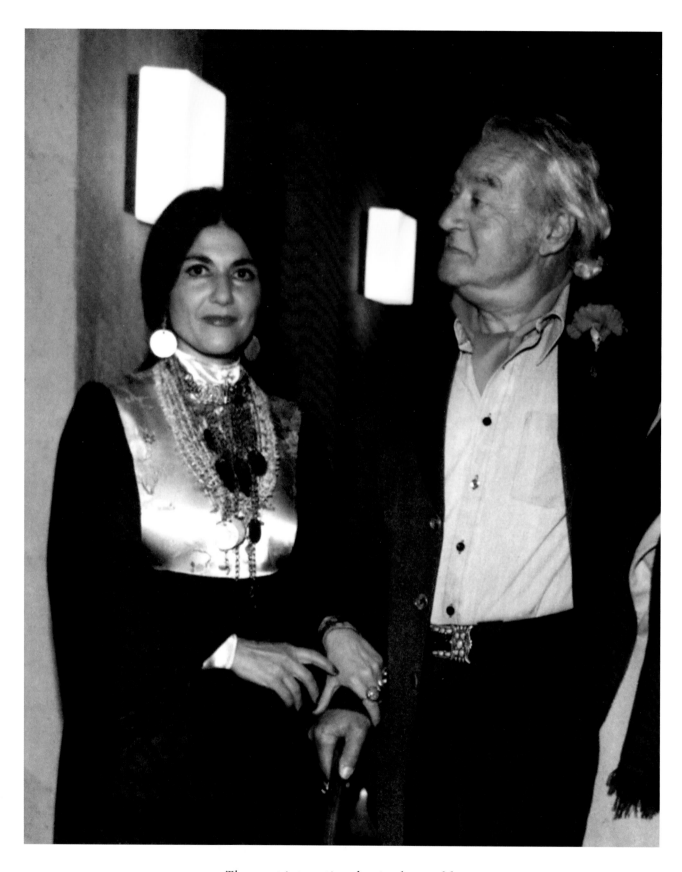

The most interesting dog in the world.

roads of the desert, where there were no phones and no water. I drove right to his front door, which was not allowed. I guess I was still a rebel without a cause.

Lew and Matilda rushed to the door and looked at me with puzzlement. Nobody ever dared to come during the week when the master was painting.

Well, it worked out. I guess I put all my charm on the table. I told them what I was trying to do with the gallery, and from that day on the three of us had very close relationship. He was a very handsome man and a great dancer, and the ladies liked him. Matilda didn't cook, and Lew liked to eat, so they figured out which of their society-lady friends cooked well and they ate at a different table each night of the week. My night was Thursday, as I was quite a good cook.

Lew was a great reader. Every morning before he started painting he would sit in the sun for two hours to read. And every evening, when he finished working, he would read. He was a smoker and a drinker. He'd put a bottle of Jack Daniels by his chair and read until the bottle was finished. Then he'd go to sleep.

It was difficult to get work from Lew to show in my gallery. His output was small—only about four paintings a year—and there was always someone waiting in line for the next painting.

One day at five in the morning, Lew called and actually ordered me to come there, right away. In his deep voice he said, "Matilda is dead. I'd like you to come here and collect all her belongings. I wish to have every bit of it out of the house." This was even before they took the body away. So, flying through the desert in my car, I acceded to his wishes. I closed my eyes and my heart, put all her belongings in sheets, and got it all out of his house.

This was how the great love affair between Lew Davis and Matilda ended.

A short time after Matilda passed away, Lew got sick from smoking and drinking, which had affected his lungs, liver, and circulation.

I took him to the hospital, and the next day when I went to see him, I was told that his leg had been amputated. He didn't make a big deal out of losing his leg and even joked about it with the doctor. "Doc, do you think I can swim with one leg?" The doctor said, "Yes, you can swim very well." And Lew, with a big smile, said, "Good, I could never swim before."

Lew Davis: Little Boy Lives in a Copper Camp, *1939. Courtesy of the Phoenix Art Museum.*

He'd been a great dancer and a man's man, but now the society ladies no longer invited him to dinner. Those ladies had come from New York or Chicago, part of a leftover generation that was very traditional and very proper. And a man with one leg is not a pretty addition to a dinner party.

I took Lew to Los Angeles to get fitted for a prosthetic leg, and again, this wonderful man still had his sense of humor. "I want a black leg. A white leg is disgusting, the color is wrong." The artist in him came out.

Lew had done a lot for the African-American community. He was awarded the Legion of Merit in World War II for building up the morale of black troops. He had designed amazing enlistment posters that showed black soldiers. His feeling was, how can you enlist black men when all your enlistment propaganda shows blond, blue-eyed soldiers?

Some of those posters and his Legion of Merit are on display at the Arizona Historical Society.

Lew Davis stopped painting and became a frequent visitor to the gallery, as he was bored. He just sat around and read—not a good situation for this great painter.

Riva said, "Lew, if you start painting again, I'm going to give you six months of my life. I'll be there in the desert, helping you with whatever you need. I'll even cook for you."

Food had always excited him. He said, "Let's do it."

I was in the studio from eight to five. I stayed in a room next to the painting studio that had been Matilda's ceramics workshop. I had some background in clay, and I thought he'd paint and I'd go back to ceramics—everything was there—and I'd watch over him.

Well, it didn't work, as the minute I put my hands in the wet clay, there was a loud sound: "RI-VA!" Lew called me every five minutes. He claimed that his paintings had to work from all sides, so every few minutes I had to turn the painting for him. He now painted from a chair, using a special easel, and it was difficult for him to get up.

In the evenings, he wanted to go to fancy restaurants. He dressed very elegantly and very Western, including a fine Stetson. But sometimes he was embarrassing, as

Lew Davis: Lonesome Valley, *1974.*

he would pee by the front entrance as people were walking in and greeting him. One night, a waiter said he was glad to see Lew with his granddaughter, me. Lew said, "I don't mind if you say 'daughter,' but 'granddaughter' is too much."

In those six months, he produced the best paintings of his life. And then he said, "I'm done. It's my birthday."

A friend brought him a cask of Jack Daniels, his favorite drink. I was there with Clare and, seeing how drunk Lew was getting, I thought I'd better stay the night in case something happened to him. I stayed in the guest room, and in what seemed like dreams I saw a white ghost flying over me, but when I opened my eyes, no one was there. I discovered that Lew had been trying to cover me with a white sheet, but he was so drunk that every time he lifted the sheet he fell down.

When I got up in the morning, the cement floor of the entire house was covered with liquor. In his extreme drunkenness, he'd forgotten to close the cask's spigot. He was asleep in a Jack Daniels lake.

My six months were over. Lew was done painting.

Some time later, I traveled to Ronda, Spain, with Lew and my daughter, Shelli. By this time Lew was no longer well, and he knew that he didn't have much longer to live. He wanted to see Ronda for the last time and perhaps die there.

Ronda is an ancient town in the mountains, not far from Malaga. Once an Arab stronghold, invaded by Christians in 1485, it still retains a Moorish flavor. It is perched on the cliffs above a deep chasm, called El Tajo, and has a dramatic history. During the Spanish Civil War, Republican forces murdered Nationalist sympathizers by throwing them off these cliffs. Ernest Hemingway, who spent many summers in Ronda, used the setting in some of his writing. In *For Whom the Bell Tolls*, he wrote of the killing of civil war Nationalists in an Andalucian town, allegedly basing this on the Ronda murders.

Spain's oldest bullfighting ring, built in 1784, is in Ronda, and Hemingway wrote of its bullfighting tradition. The town is the birthplace of modern bullfighting, in which the matador stands his ground on foot against the bull, rather than mounted on horseback.

Orson Welles was a resident of the town in his youth, and his ashes are buried there on the estate of a famed bullfighting family. Welles once said, "A man is not from where he is born, but where he chooses to die."

Rainier Maria Rilke also wrote of the town. A life-sized statue of him sits in the garden of the hotel where he lived in 1912. His hotel rooms are preserved as they were when he lived there.

In this mountain village, you can feel in the air the culture of the people who had lived and died there. From my first moments in Ronda, I wanted to spend the rest of my life in this village, even before I knew that all the greats had felt the same.

Magic happened when we got in a taxi and drove very slowly down the Tajo. At the bottom of the canyon was a very old lady, all dressed in black. Her arms were completely filled with flowers and she was gathering still more. Obviously she'd come down the Tajo on foot. She'd begun the pilgrimage back up, carrying the huge, heavy bouquet of flowers. We told the taxi driver to ask her if she would like a ride back up to the village. She got into the cab and, smiling broadly, said, "I was never in a taxi before."

When we arrived in the village, she got out and handed me all the flowers. It was the most wonderful gift I'd ever received. I will never forget her smile and the sparkle in her eyes. After all that work of gathering the flowers, she gave them to me.

Shelli had her own adventures in Ronda. She was thirteen and fell in love with every young waiter. They were all named Paco, short for Francisco. Those young waiters would recite poetry for her and would look at her and say, "You are as beautiful as a butterfly." An American teenager never heard such words before from a boy. They were all perhaps fifteen or sixteen. She would sneak into the garden at night and kiss behind Rilke's stature. I had to promise her that we would name our next dog Paco, and we did.

I think I would like to be buried in Ronda.

The day after we arrived in Ronda, the hotel concierge handed us a card in a beautiful gold envelope. It was a very elegant invitation addressed to Lew Davis and his companions. The invitation was to visit the home of Mr. Ronald Smith, an American, for cocktails. So of course we went. He lived in a big beautiful house in the mountains. We were greeted by a very fancy-looking American in a white suit for an elegant

cocktail hour, with all sorts of delicious hors d'oeuvres. We were treated like celebrities. We had such a beautiful time, and just before we left, a white-gloved waiter presented us with a little silver tray. On the tray was a bill—a huge bill.

Later we found out that this American had a connection to the hotel concierge. Whenever the concierge let Mr. Smith know that rich Americans were staying at the hotel, he would invite them to his house. This was how he made his living.

Lew Davis died in Arizona at age sixty-nine.

With Jim at his home in Oracle, Arizona.

XXXII
THE ARTIST JAMES G. DAVIS

The painter James G. Davis is a most eccentric and interesting person. He lives on a former dude ranch, Rancho Linda Vista, in southern Arizona. This ranch is an intentional community, and the residents are writers, painters, doctors and philosophers.

His wife, Mary Anne, is in all his paintings, which are large, surreal, mysterious, and beautiful. Jim loves women, so the women in his paintings are always exquisite. His works are so painterly, at points so thick with paint—a chunk of red, perhaps—that Jim calls this "bleeding the painting."

This story will explain a lot about Jim: He came to visit the gallery. I was very busy, and I left him in the house to wait for me. Douglas put a bottle of tequila in front of Jim. Big mistake.

Jean and Krishna Reboue got off the plane from Paris and came directly to the gallery, which was always their first stop in Arizona. As I was busy, and forgetting that Jim Davis was still there with a bottle of tequila, I told Jean and Krishna to wait for me in my house. Krishna is the niece of the poet Tagore. Always dressed in saris, she is very aristocratic and attractive. Her husband is elegant and one of the most brilliant men in France.

There they were—the three of them together in the house. Krishna raved to Jim about the Cezanne show she had just seen in New York. Jim, after finishing the bottle of tequila, said, "Fuck you and fuck Cezanne." Then he turned around and said to her, "But you are so beautiful."

After that initial shock, Jean said to me, "We like him; we'd like to have him to dinner at our house." Jean and Krishna Reboue got to know Jim better and to understand the intensity and depth of his work, and they became collectors of James G. Davis paintings.

Some time ago, on August 17, my birthday, Jim Davis gave a party for me at his house on the ranch. He invited most of the ranch people, at least a hundred of them.

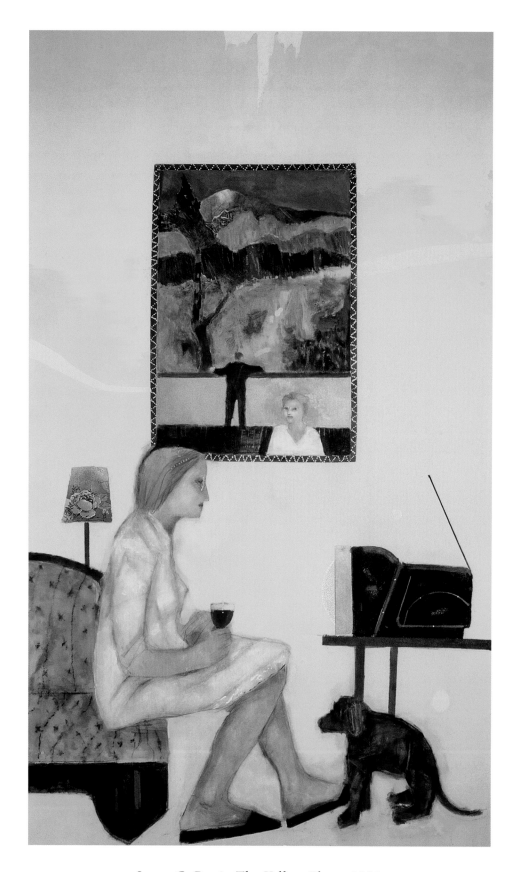

James G. Davis: The Yellow Elegy, *2006.*

Douglas and I decided to surprise them by coming to the party in costume. I wore a red saloon-girl outfit—strapless red satin—and a feather in my hair. Douglas dressed as a Union soldier from the Civil War.

We arrived in a very fancy sports car. The ranch people spotted us through the windows of Jim's house, and when they saw our costumes, they ran (they looked like a herd of mice) back to their houses to change clothes. They all came back with very colorful outfits. It was a time of dressing up, and they all loved it. There was the Frieda Kahlo Club for the women—they dressed up like Frieda, in colorful Mexican skirts and blouses—and the Nairobi Shooting Club for the men. Their club symbol was a broken gun, as they were against shooting. It was a great party, with lots of music and singing—and drinking.

After midnight, I went to bed in Jim's house. Their son, Turner, slept at a friend's house so that I could have his bed. As soon as I got into bed, a very drunk Jim crawled into the bed with me. I screamed, but he wouldn't move. He said, "If you don't like it, go to a motel."

I did not go to a motel, and he got out of my bed and left me alone.

I'm afraid of drunks.

Like many with drinking problems, when he has had a few drinks, Jim becomes nasty, obnoxious, and impossible to be with. But when he's sober, he is shy and poetic.

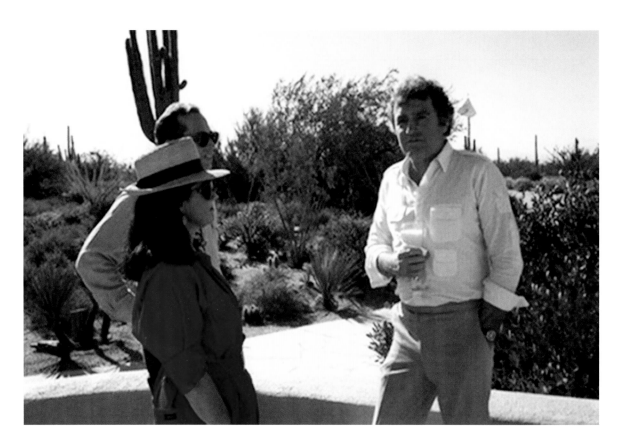

Riva with Fletcher Benton.

XXXIII
FLETCHER BENTON

Fletcher Benton was the recipient of the 2008 International Sculpture Center Lifetime Achievement in Contemporary Sculpture. Past recipients of this prestigious award include Manuel Neri, Magdalena Abakanowicz, Louise Bourgeois, Sir Anthony Caro, John Chamberlain, Eduardo Chillida, Christo and Jeanne-Claude, Mark di Suvero, Claes Oldenberg and Coosje van Bruggen, Nam June Paik, Gio Pomodoro, Robert Rauschenberg, George Rickey, George Segal, and Kenneth Snelson.

Fletcher's sculpture takes over. It's massive, beautiful, and intriguing—just like he is. It is displayed in public places all over the world.

Fletcher and I have been very good friends for many years. When Fletcher thinks of Riva, he sends Riva red roses. This happens often.

Riva likes chairs—Fletcher likes chairs. I admired a chair made of bronze that I saw in his San Francisco living quarters. I spent an hour in front of it. I loved it. It was life-sized but sat on a turntable, so that it could be seen from different angles. He sent it to me for my birthday. It is my prized possession. Maybe I should be buried on it.

All women love Fletcher Benter, and all men respect and admire him.

Very good dog.

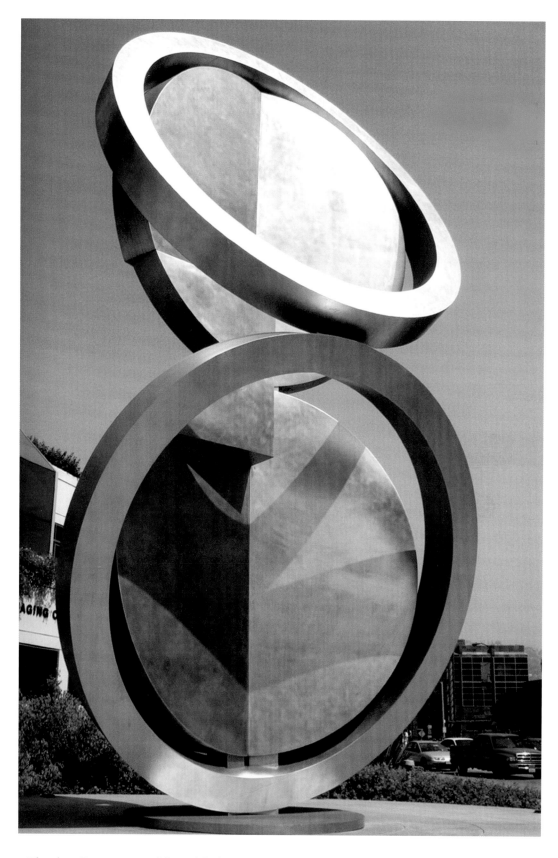

Fletcher Benton, Double Folded Circle, *Cedars-Sinai Medical Center, Los Angeles.*

Benton's San Francisco studio (Alphabet Series).

Meeting Esteban Vicente for the first time.

XXXIV
Jimmy Ernst—Party in East Hampton

Max Ernst was a good friend of Lew Davis. Max and Dorothea Tanning had spent time in Lew's house in the Arizona desert after Max escaped Peggy Guggenheim in New York. Jimmy Ernst was Max's son and a painter. He lived in East Hampton, where he and his wife were very social. I showed some of Jimmy Ernst's work in the gallery in Scottsdale.

One summer evening, Jimmy and his wife, Dallas, threw a big party in East Hampton. I was invited and came with Douglas. Very suntanned from the Arizona summer, I wore a white Mexican wedding dress and my long black hair loose around my shoulders. Douglas wore all white, and at the time he was in perfect shape. Most of the people there were artists, so Douglas and I drew a lot of notice. Maybe they thought we were dancers, the entertainment for the evening.

At that party, I met several artists who interested me a great deal—Esteban Vicente among them. Vicente was a Spaniard who lived in New York and had a house in Bridgehampton. I was invited to his studio. We had a great time together; I made a good connection; and he agreed to show with me. In his Spanish accent, he said, "Riva, you are my only dealer from now on."

At that same party I also met and made a really good connection with Balcomb Greene. I was invited to dinner at his house, built on a cliff at Montauk, at the tip of Long Island. This turned out to be a most elegant—and odd—dinner party. Balcomb was in his seventies—very thin and very tall. About ten people sat around the table, enjoying great conversation. For the main course we had marrow bones. Then a very strange thing happened. In the middle of all the talking, Balcom dropped his head onto his plate, full of bones. Nobody paid much attention. After five minutes, he lifted his head and continued the conversation as though nothing had happened.

In East Hampton, I tried to charm every artist I wished to show, and it worked. I didn't have money to buy the work, so I had to use my personality. I guess I was a little different from the New York dealers.

Max Ernst and Dorothea.

With Balcomb Greene.

Andre Emmerich.

XXXV
Andre Emmerich

Andre Emmerich was the major dealer of contemporary art in New York, especially of the color-field school. I wrote a letter to him, saying that I would like very much to meet with him. I received a reply that he would be in Arizona shortly to play tennis and that he would love to meet with me. After a few weeks, he did come to the Southwest and visited my Scottsdale gallery. He was very impressed with my operation, with my doing the impossible in the desert.

Andre Emmerich gave me a standing invitation to come to his New York gallery and have lunch with him. When I went to New York a short time later, he and his assistants had a grand lunch for me. I was the guest of honor. After lunch he took me around the gallery, which was filled with all the artists I admired. It was like being with friends that I hadn't seen in a while. This wonderful man said to me, "You can take anything you wish from my gallery to show in the Southwest, and when you sell it, then you can pay me." I was so impressed, and very happy—my life was going in the right direction.

After that, whenever I went to New York, I would go to his gallery to choose works to show. Whenever I saw him, he would always offer encouragement, telling me that I shouldn't be discouraged; he would say that Arizona is still part of America.

Andre Emmerich died in 2007. He has a warm place in my heart, as he's the one responsible for my being considered a serious art dealer early on, even though I was in Scottsdale, Arizona. He took great pride in my success.

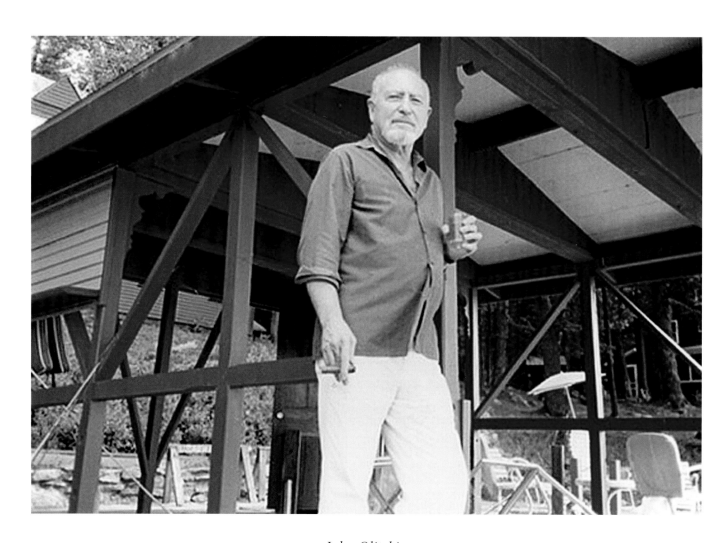

Jules Olitski.

XXXVI
JULES OLITSKI

I wrote a letter to Jules Olitski, as I wanted very much to show his work. He responded by inviting me to his island in Vermont. That summer, I went to Vermont, and Olitski sent someone to pick me up in a small boat. When I arrived at the island, there was Olitski, a large man with soft eyes, holding a big glass of Scotch, at ten in the morning. I liked him immediately; he was a very warm and attractive man. He was just about to go to sleep, as it was his habit to work at night and sleep during the day. His wife, Christina, a young and beautiful Greek lady, welcomed us, and we went to the house. We talked for a while and had a beautiful lunch. Olitski didn't go to sleep that day. Instead, we went to his studio.

How interesting it was to me that most of the canvases were lying on the floor, as that's where he painted them. They were thickly textured, and he covered the whole canvas in this way. This was the beginning of a new style for him, as the earlier works were much more minimal and painted very thinly.

We met again for dinner, and then after dinner everybody went to sleep except Olitski and me. We stayed by the dinner table and talked—all night. We didn't talk about art. We talked about Jewish literature, with which he was so familiar, and so was I. I think this was the magic. Talk to an artist about any subject other than art, and he will love you. And that's how my relationship with Jules Olitski began.

We did a few shows in Scottsdale of his work. Olitski came with Christina, and we made a great exhibition.

Jules died in 2007. I love you, Jules Olitski.

Riva all in white next to a man of color.

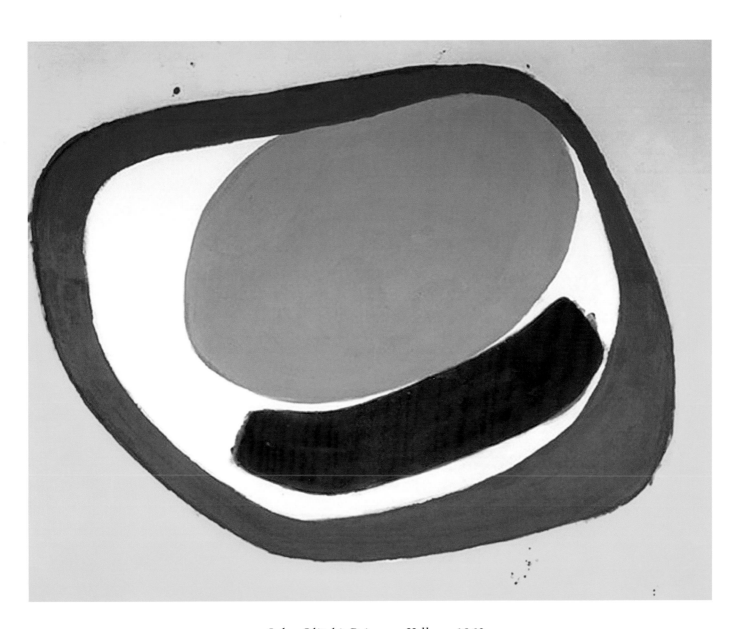

Jules Olitski: Princess Yellow, *1962.*

Esteban Vicente.

XXXVII
ESTEBAN VICENTE

Esteban Vicente—a good-looking man, a very temperamental man. He was one of the artists I had met at Jimmy Ernst's party in Easthampton. Ours was an immediate connection. Born in Spain, he spent his youth in Paris, and the rest of his life in New York City. His blood was red, and so is mine. This was the connection: the temperament.

I was invited to his studio in Bridgehampton and then to his home and studio at the Hotel des Artistes in New York City. What a strong and smart man was Esteban. When people asked him the secret of life, he would say, "When you get up in the morning and put your feet on the ground, this is life, and all the rest is politics." He was aloof and proud—and he didn't suffer fools.

It's not difficult to describe his paintings. He told me, "Life is ugly enough, so I make beautiful paintings." His colors are right out of his Bridgehampton garden, which was full of flowers every summer. The color-field paintings that he began focusing on in the 1960s were luminous and elegant, and the colors passionate, as he himself was.

One time he said, "New York is hell, and hell is the only place for people to live." Sometimes he was insulting and had a caustic wit. He loved me, and I did the most powerful exhibitions with him: "Esteban Vicente in Arizona" and "Esteban Vicente in Santa Fe." He did a ten-painting series—all large red-and-black paintings—which he called the Riva Series.

One cold New York evening, Esteban, his wife Harriet, Douglas, and I went to a restaurant called Bouley. Daniel Bouley is a great chef and a collector of Vicente's paintings, and that night we sat beneath one of the Vicente paintings that hung in the restaurant. Every dish Bouley served us that night was inspired by Vicente's colors. Good memories. Every so often Bouley would arrive at Vicente's midtown studio with a wonderful lunch. He would tell Vicente, "I just want to watch you paint."

There is a museum in Segovia called the Esteban Vicente Museum of Contemporary Art. On the museum grounds is a garden where there is a large rock. Vicente's ashes are buried beneath it.

As exquisite as his paintings are, parts of his life were quite tragic. His little daughter, Mercedes, from his first marriage, died at the age of six from scarlet fever. He was close to the daughter of his third wife, Harriet. That daughter died of a drug overdose.

The Gentleman Artist.

Esteban loved young people and was a great teacher. His students adored him. He was a founding member of the New York Studio School, where he taught for many years. In 1991, at the Prado Museum, he was presented the Medal of Honor in the Arts by King Juan Carlos of Spain, an honor that had also been given to Picasso and Miro.

I love you, Esteban.

Esteban Vicente was born in Turegano, a small village near Segovia in 1903. He died in Bridgehampton, New York, in 2001. He was ninety-seven.

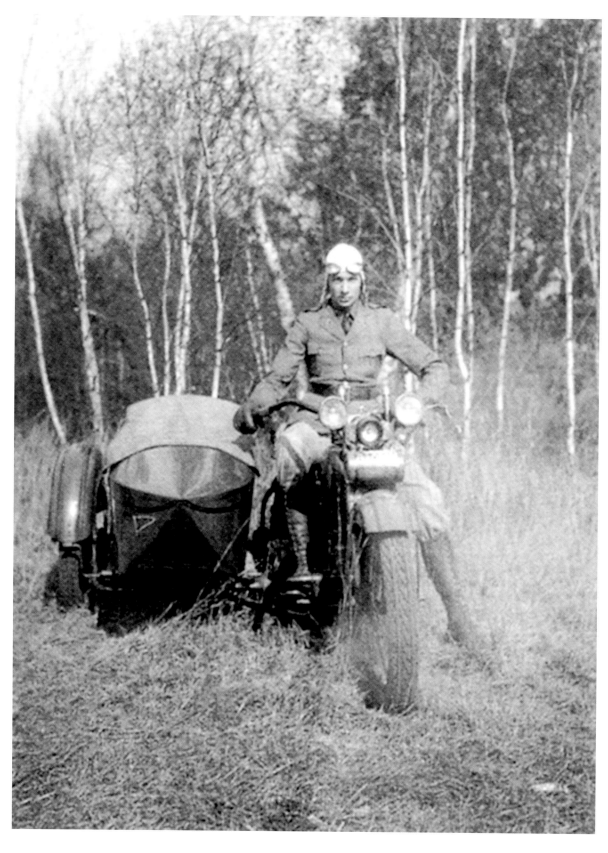

Robert Kittredge. Photo courtesy of the Kittredge family.

XXXVIII
A PORTRAIT OF ROBERT KITTREDGE

Robert Kittredge was one of the giants among the men in my life. I feel very lucky to have known him. He and his brother, who had just finished medical school, lived on the East Coast.

Robert Kittredge dreamed about a place in America. He got up one morning and told his brother the dream. They bought a Harley-Davidson with a sidecar and went to look for that dream. They rode the motorcycle from New York all the way West. The sidecar carried his brother, a pet monkey, and an orphaned coyote pup. When they hit Oak Creek Canyon, north of Sedona, Robert Kittredge said, "This is where I'm building my country."

So Robert and his brother, with their bare hands and strong arms, built a dozen houses on Oak Creek, calling them the Forest Houses. Robert brought his bride-to-be, Mary, an elegant, fragile, born-to-money woman, to his country. They had a son.

When Max Ernst and Dorothea escaped New York to stay with Lew Davis in the desert, Lew introduced them to Kittredge. Max and Dorothea settled in Sedona.

Bob Kittredge could do anything. He decided that he wanted to go around the world, but in a boat that he himself built. So he and Mary and their young son, Robert, built a boat and traveled around the world. Bob wrote a book about that trip.

We became very good friends, as Bob decided, after the around-the-world voyage and after he wrote the book, that it was his time to be a sculptor. He made the most original and startling bronzes of horses. I did an exhibition for Robert Kittredge.

He had few friends; for the most part he didn't like people. I was one of the lucky ones. In his later days, he built an aluminum house, with a tower that protected from the outside world. In the top of the tower was his room, where every afternoon he would play the concertina.

His brother was a doctor in Flagstaff, who would treat the Navajos when no one else would take care of them.

"If you can keep your wits about you while all others are losing theirs, and blaming you . . . the world will be yours and everything in it; what's more, you'll be a man, my son."

—Rudyard Kipling.

That's why Bob Kittredge liked Riva.

The last kiss . . . I love you, Matta.

XXXIX
ROBERTO MATTA

The artist I have admired throughout my life is Matta, and he was my friend. I could not have achieved more than to have Matta, the artist and person, be part of my life.

I went to see Matta in Paris to put an exhibition together. I spent two days with him in deep conversation and caught his words in my hands. He was so very brilliant; being in a room with him for even a moment of time was like traveling relentlessly through his space and his mind.

—Riva Yares

A few people are partly responsible for my success in the art world; Jean and Krishna Reboue are among them. Jean was the CEO of Schlumberger and quite a figure in the worlds of art and politics in France. He was a native of France, and Krishna was from India. They lived in Paris and had a vacation house in Carefree, Arizona. They were good friends of Lew Davis.

When I visited Paris, they introduced me to Roberto Matta, a painter whom I admired, one of the great surrealists of our time. Matta and I hit it off and became friends. When I met him for the first time, I was wearing all white—a white suit with a white hat—and the first thing Matta said to me was, "But you are so elegant, my dear. You have to come and visit me in Tarquinia at my summer house."

I did go to Italy to visit Matta. He lived in an old monastery that had a hundred rooms, eleven dining rooms, and an incredible painting studio that had been an old chapel, with a high rounded ceiling covered in frescos.

I spent a few days with Matta and his wife, Germana. At five every day, Matta would have guests. We'd sit under a big olive tree, and the butler would bring a large silver tray, on which there was ice, bourbon, fresh mint, and sugar. Then Matta would perform the daily ritual of making mint juleps.

Matta was an amazing person, and I wanted to catch every word that came out of his mouth. He spoke many languages, and his English was perfect.

We made a great connection, and I started to show his paintings very successfully. In 1980, I showed Matta's work for the first time in America since 1945. He had spent the years of World War II in New York and had returned to Paris when

The greatest surrealist of my life.

the war ended. He wasn't very well liked in New York, as there was a rumor that the artist Arshile Gorky had hung himself because Matta slept with his wife. According to Matta it was not true, and he left America quite angry.

After my visit, Matta went to Japan, where he was well-loved, to accept an award from the Japanese government. One morning, he got up and said to his wife, "Let's go to Arizona and visit Riva." They did come to visit me.

The Phoenicia Hotel in Scottsdale invited Matta to stay in their presidential suite. It had a white grand piano, two bedroom wings, and a big Jacuzzi on the balcony facing the mountains. After a day in this suite, Mrs. Matta decided that she didn't like it. It was too big and she couldn't find Matta, so they moved to a regular room.

I was very proud to show Matta's paintings in America after so long an absence, and I kept showing his work on a regular basis.

Roberto Matta was born in Chile in 1911 and died in Paris in 2002. Matta will stay forever in my heart.

Jesús Soto.

XLI
JESÚS SOTO—CARACAS AND PARIS

I saw Jesús Soto's creations as having the most original movement and colors. I admired him and wanted his work for the gallery, so I went to Paris to see him. Soto was born in Caracas and lived in the Marais district of Paris with his French wife.

Soto was a very good-looking man, being tall, bright-eyed, with a big mustache. It was hard for me to communicate with him, however, as I didn't speak Spanish or French, and Soto didn't speak English. I brought along "the marquis," Jean Michel, to be our intermediary.

I went to Soto's studio, on the bottom floor of his house, to see his work. Then we went to lunch and had a very great and elegant time. In our company were the director of the Jeu de Palme, the marquis, and Madame Soto.

When lunch ended, Madame Soto suggested that Soto and I take the small elevator and the rest of the party walk up the stairs. When the elevator door closed, Soto began caressing my face, telling me in Spanish that I was so beautiful. Then he kissed me and put his tongue in my mouth. It was the most embarrassing moment. I couldn't deal with it, and then, thank God, the elevator opened.

Later, when we took a walk in the Marais, Soto said, "If you want to show my paintings, you have to come to Caracas to see my major pieces." I did go to Caracas, a month later, by myself.

I would go to the ends of the earth to understand an artist whose work I really wanted to show. I had the gift of knowing what the artist would paint next, even before he knew it himself.

Even though friends had told me that women don't go by themselves to Caracas ("they don't just steal your watch, they cut off your hand in the process"), I arrived in Caracas alone after midnight. I had been instructed to look for a man with a black beard, holding a newspaper, who would be my driver. The airport emptied and there I was, looking for the black-bearded man with a newspaper. Finally I found a man with a white beard, holding a book—and eventually arrived safely at the hotel. During the drive, I saw in the mountains twinkling lights and imagined that these must be wonderful villas. In the morning, when I looked out the window of my hotel room, I saw that they were the cardboard shacks of the poor. In Caracas, the rich are very rich, and the poor are very, very poor.

Riva and Soto in Paris.

One night, Soto and I went to dinner at the home of a wealthy collector. As we approached his imposing villa, we had to pass by a guardhouse, with men carrying machine guns. The house was exquisite, filled with great art. I asked myself, would Riva like to live this way, in such luxury, surrounded by wonderful things, but having to be guarded with machine guns twenty-four hours a day? The answer was no, no, no.

The next day I had breakfast in the hotel with Soto, his secretary, and his bodyguard. We traveled through the city and saw the grand Soto public artworks. Soto was world famous as a kinetic sculptor. The public pieces were known as "penetrables," interactive sculptures made from thin, dangling tubes. People could walk right through these fascinating works of art.

One of my great achievements was getting Soto and Matta together. They hadn't seen each other in fifty years, even though they'd lived a few blocks apart in Paris. Matta was having a show in Caracas and was at the same hotel where I was staying. I told him that Soto was in the city. There was a party at Soto's house and Soto's mistress was there, a beautiful young Venezuelan woman who happened to be a professor of mathematics. I brought Matta with me. Matta and Soto looked at each other, and they both said the same thing: "But your hair is so white."

I put together several Soto shows in Scottsdale and Santa Fe. The day that his 2005 show opened in Scottsdale, Soto died in Paris. He is buried in the Cimetiere du Montparnasse. Soto was eighty-one.

Jesús Soto was born in Venezuela in 1923. He died in Paris in 2005.

Jesús Soto: Cobalto y Oliva, *1985.*

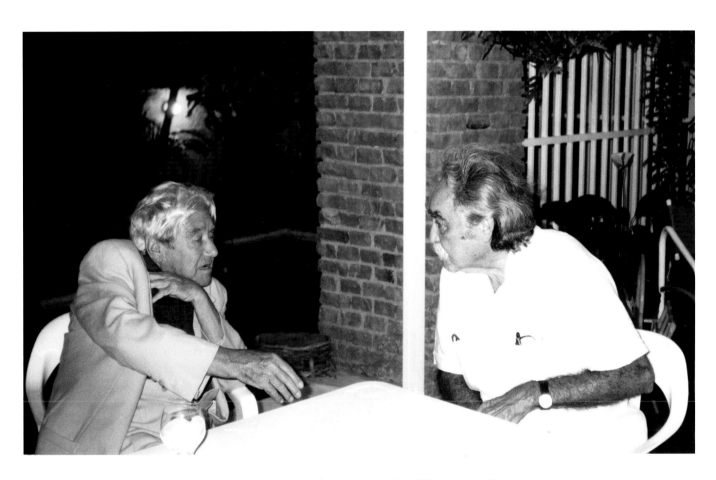

Matta and Soto, together again after fifty years, Caracas.

The Holy Ghost.

XLI
THE MAGIC OF YVES KLEIN

This story is not about Yves Klein but about his wife and the mother of his only son, also named Yves. Rotraut Uecker Klein was my very best friend. We were more like sisters until a black cat came between us. We traveled together, wore each other's clothes, and had a very intimate relationship. From her I learned about her life with Klein. She had come from Germany to Nice to be a nanny for the son of the French artist Arman. One day the doorbell rang. When Rotraut opened the door, Yves Klein was standing there. His black eyes looked her over. Love at first sight. They got married.

With Rotrauts's help, I produced a Klein exhibition in my gallery in Arizona, which then traveled to the Fuji Gallery in Tokyo. I took great pride in this achievement, as I had admired Klein's work for so long.

Klein was born to two painters, Fred Klein and Marie Raymond. This master of the French avant-garde died in Paris in 1962 at the age of thirty-four.

One day on the beach in Nice, Klein had signed the sky, dating his aesthetic from that moment. He detested birds, saying it was, "Because they tried to bore holes in my greatest and most beautiful work."

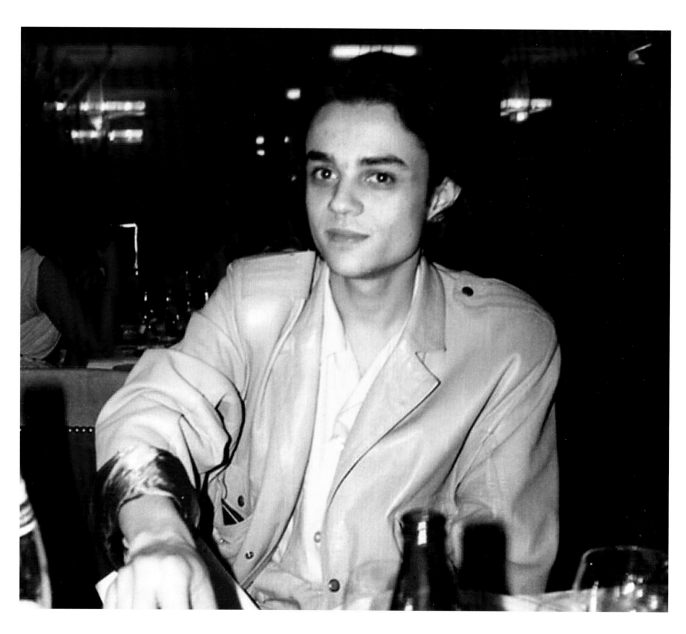

Yves Klein, Jr., the son.

Rotraut, the wife.

Arman, the cutting edge of the new realists.

XLII
ARMAN—EVOLUTION OF WORK

Arman, along with Yves Klein, Jean Tinguely, and six others, was a founder of the Nouveau Réalisme movement. Their manifesto identified the group's purpose as "new ways of perceiving the real." They wanted to reformulate the roles of art and the artist in the face of consumer society, and to reassert humanist ideals in an industrial age.

Arman is best known for his "accumulations"—sculptures or paintings made from collections of common, identical objects—which he began creating in the late 1950s. These collections were arranged in polyester castings or within Plexiglas cases or, later, welded together. The tower of cars in front of the Fiat plant in France, as well as other very large pieces created for industrial sites, made him a world-renowned figure.

Because I adored Arman's work and his great mind, I often traveled to Europe when he had exhibitions there, and we became friends. I did a few shows with Arman. The originality and intensity of his work will stay with me and the world forever.

Arman was born in Nice, France, in 1929. He died in 2005 in New York City at the age of seventy-six.

Arman: Wheels of Fortune, *1995.*

Balthus. Photo courtesy of Assouline Publishing.

XLIII
LIVING WITH BALTHUS

Count Balthasar Klossowski de Rola, known as Balthus, was one of the greatest painters of the twentieth century. Born in Paris in 1908 to Polish aristocrats, he was an obsessive observer and a draftsman of great precision, who sometimes spent years on a single painting.

While walking through the Basel Art Fair, I was stopped in my tracks in front of one of the British galleries. There I saw a most magnificent large Balthus painting, *Young Girl with Mandolin*. It took my breath away. I wanted this painting. I had to have it. I bought the painting, even though I'd never before spent millions on one work. It influenced my selection of the young actress to play the lead in my movie, *Jolene*, and is now hanging in my penthouse. Balthus lives with me every day.

Thank you, Balthus.

Balthus died in Rossiniere, Switzerland, in 2001.

"I could never paint a nude woman. I find the beauty of young girls more interesting and perfect than women's. They embody becoming, a pre-being; in short, they symbolize the most perfect beauty. Woman is a being already situated in the world, whereas the adolescent—from the word adolescere, *"to grow"—hasn't yet found her place. A woman's body is generally too defined: a girl's body is more beautiful* (he laughs). *It's precisely this whole matter of young girls that has caused the misunderstanding about my painting. To classify my work as erotic is idiotic. Young girls are sacred, divine, angelic beings. Finally, the only thing poor Nabokov and I have in common is a sense of humor."*

—Balthus (*Balthus, In His Own Words*)

My Balthus, Odalisque a la Mandoline . . .

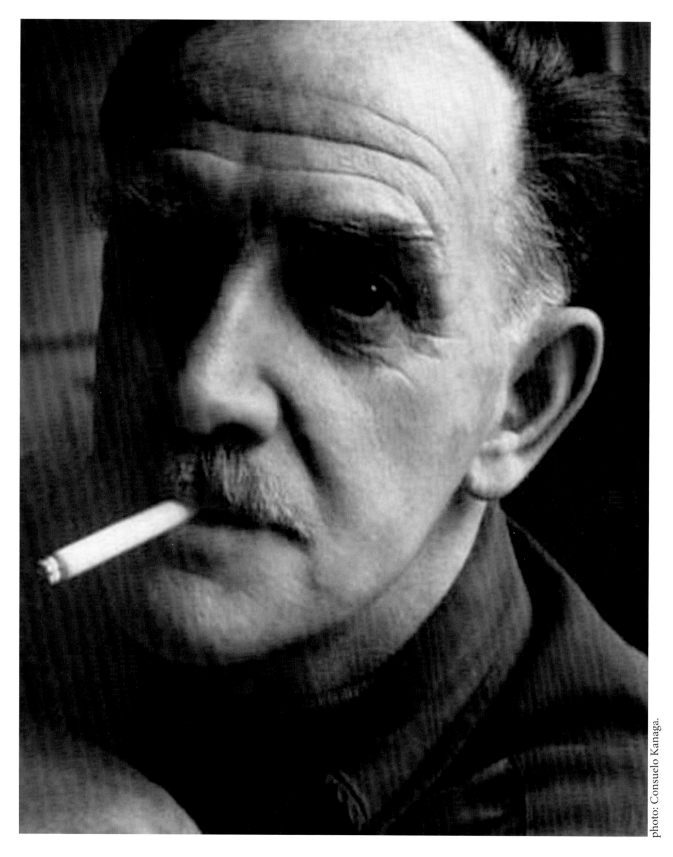

photo: Consuelo Kanaga.

Milton Avery.

XLIV
MILTON AVERY—AN AMERICAN ORIGINAL

I was not lucky enough to know Milton Avery during his lifetime, but I became very friendly with his widow, Sally Michel. I met Sally at a party in Easthampton at the home of Jimmy Ernst, and I told her how much I would like to show Avery's paintings in the Southwest. A few trips to New York and a few dinners with her later, she said, "Yes, I would like you to handle Milton's works."

So, since the late sixties we have been showing Avery's work very successfully. In addition to shows at my galleries, I was involved with several Avery exhibitions around the country. I sent paintings to the Phillips Collection, and I curated a major exhibition in Milwaukee, in the fabulous museum designed by Santiago Calatrava. The city was full of banners—Milton Avery and Riva Yares Gallery at the Milwaukee Art Museum. I felt great pride as I walked out of my hotel and saw the banners leading to the museum.

I'm thinking now how hard it was to get to show Avery's works, as everyone wanted them, and I was just an unknown in far-off Scottsdale, Arizona. As a dealer, I would talk, I would charm, I would be there anytime—very much like a European dealer—not like an American dealer, who would come with a bag of money, which I didn't have.

Then Sally Michel and I became very good friends. Whenever I had a show of Avery's work in my Scottsdale gallery, she would appear with her entourage and stay for a few days. She wanted me to escort her to a show of Milton's work in the Denver Museum; so it was Sally, and the critic Hilton Kramer, and I. We had a grand old time.

Sally would take me to parties in New York City. One night we went to a party at the Art Students' League. On each floor there was what was called a "Happening." On the third floor, in the middle of the room, was seated a naked, 350-pound woman with rolls of fat on her belly. We were each given a pad and pencil to make a drawing—this was part of the entertainment.

Sally had the spirit of a young girl, until that spirit disappeared with her body. Years ago, Sally fell into a coma. She stayed in that condition for many years and received twenty-four-hour care in the New York apartment that she'd shared with Milton.

Milton Avery, White Moon, *1957.*

Emotionally, I found the prospect of visiting her very difficult. Her family, who knew how much she liked me, insisted that I come to see her, just to see if there would be any reaction when she saw me. Finally, I did go there. I walked in and waited for her caretaker to wheel her into the living room. My heart stopped when I saw her, then all of a sudden she opened her eyes and smiled—the special smile that Sally Michel had. This was my good-bye to a good friend.

Milton Avery, Lone Bather, *1960.*

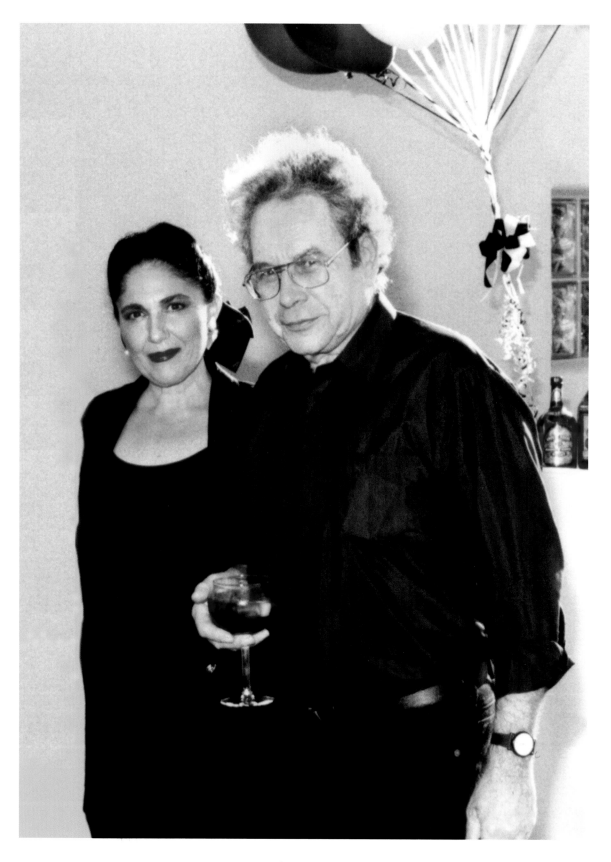

Riva with George Segal.

XLV
GEORGE SEGAL

Twenty years ago, when I built the large addition to my existing gallery, I thought that a show by George Segal would be very impressive. Having Segal's work in this amazing large space would be a dream come true.

Segal's sculptural figures have very little color and minimal detail, which give them a ghostly appearance. His larger works are usually placed in anonymous environments—a street corner, a diner, or a standing figure looking out the window. In the grand space of my gallery, the white figures looked like ghosts.

When Segal and his wife came to the exhibition, we had a big celebration. People came from all over to meet the great artist and wander amidst his work. It was almost like a miracle in the desert to have such a large exhibition of Segal in Scottsdale, Arizona.

Segal lived and worked on a chicken farm in South Brunswick Township, New Jersey. Each year, he would give a picnic for his art-world friends, and the art performances that took place on his farm inspired the artist Allan Kaprow to coin the term "Happening."

George Segal was born 1924 in New York. He died 2000 in New Brunswick, New Jersey.

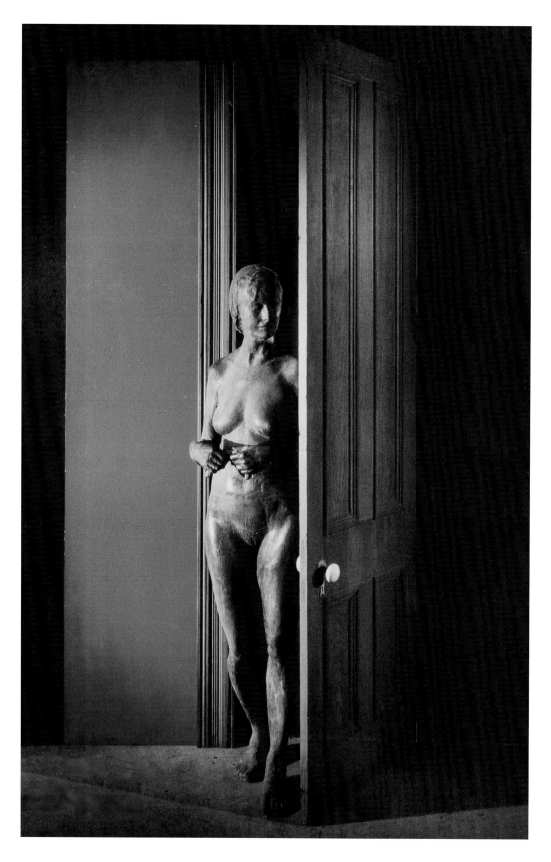

George Segal, Blue Girl behind Blue Door.

George Segal installation, Scottsdale.

Morris Louis. Photo courtesy of Diane Upright Fine Arts, LLC.

XLVI
MORRIS LOUIS—THE OPERA

The only way to describe Morris Louis's paintings is as grand opera. I did not know him in his lifetime. I knew him through his paintings and through his widow, Marcella. She and I spent time together when she came to a show I put together in 2004. I was able to assemble most, and catalogue all, of the twenty-one paintings selected by Clement Greenberg in 1960. It was like revisiting a painterly dream forty-four years later.

Morris Louis and Marcella lived in a very small house in Baltimore, Maryland. A converted dining room, measuring about thirteen-by-thirteen feet, was his studio. It remains a mystery how he was able to create his huge magnificent paintings in such a restricted space. These abstractions were so new to the naked eye of the public that nothing sold at that time. Marcella supported them by teaching school.

Morris Louis died young, only forty-nine, from lung cancer. The fumes of his new medium and his smoking killed his lungs. He left behind the most beautiful paintings for the world to enjoy. I have him in my living room, where he lives forever in his world of color.

Morris Louis, Devolving, *1959.*

Morris Louis, Number 1-99, *1962.*

183

Kenneth Noland.

XLVII
KENNETH NOLAND

I went after artists that I admired, and the American abstract painter Kenneth Noland was one of them. Noland invited me to his great studio in Vermont, where the grounds were filled with his sculpture. He and I sat and talked about the work.

Early on in his career, Noland was best known as a color-field painter, later as a minimalist. In the 1950s, he met Morris Louis and they became good friends. Noland was concerned with the relationship between the image and the picture edge, which led him to create a well-known series of bull's-eye, or target/circle paintings, consisting of concentric rings in unusual color combinations. This led him, as well, to pioneer the use of the shaped canvas.

His work has been exhibited at museums throughout the world, including a major retrospective at the Guggenheim Museum in New York and the Hirshhorn Museum in Washington, D.C.

As it happened, I ended up not doing a show then, as the work I saw at that time was not to my liking, but years later I put together a grand show of his target paintings, which I loved.

Ten years after that show he passed away.

Kenneth Noland was born in Asheville, North Carolina in 1924. He died in Port Clyde, Maine, in 2010.

Riva with Kenneth Noland.

Kenneth Noland, Blue Extent, *1962.*

Robert Graham.

XLVIII
ROBERT GRAHAM—GREAT SCULPTOR
OF THIS CENTURY

I wanted very much to show Robert Graham's sculpture. It was difficult, as he didn't wish to have a gallery. Collectors had to visit him at his studio in Venice Beach, California, where he lived with his new bride, the movie star Angelica Huston.

One day, I received a message from him that he would be happy to see me, and he invited me to have lunch with him and Angelica. It was a successful lunch; we liked each other. Angelica was very lovely, very feminine looking, not as she appears in her films. Then we went to his studio and Angelica disappeared. He wanted to show me the house that he had built for his wife, as architecture was in his blood. We went through the studio, then he took me around the house and brought me to a grand room, saying that this was Angelica's room.

Then he asked, "Would you like to see my quarters?" and I said yes, and there we were. It was only a bathroom. He said, "This is where I live." His clothes and other belongings were in the tiny room. He admired Angelica so much and treated her like a queen. He was her man.

It was a very good meeting. We saw eye-to-eye on many things. At the end of it, he agreed to show his sculpture in the gallery, which made me very proud.

After I said good-bye that night in Los Angeles, I went to the opera. During the intermission, one of Robert Graham's assistants greeted me with a gift from the artist. It was a beautiful plaster wall piece that brought tears to my eyes.

Robert Graham was a great-looking man who was admired by men and women—and by me. He died in 2008 at the age of seventy. I miss him.

Riva with Ossorio.

XLIX
ALFONSO OSSORIO, THE ARISTOCRAT AMONG ARTISTS

Alfonso Ossorio was born in 1916 in Manila to wealthy Filipino parents, the owners of a sugar plantation. After his early education in England, he moved to the United States, where he studied art at Harvard. His early work was Surrealist. A great admirer of Jackson Pollock, he collected many of his paintings, which I was able to see in his grand house in Easthampton. Jackson Pollock considered Ossorio a very good friend.

I liked Ossorio's work, which appeared wild and primitive and sophisticated all at the same time. I went to visit him on his Long Island estate, which was called The Creek. In the beauty of the gardens and his sculpture, I felt like I was Alice in Wonderland. He had created his sculptures by using the growing trees (perhaps twenty feet tall) and cutting them at ten feet so that they made bases for his sculpture. The pieces themselves would continue up in surreal, organic shapes, all in primary colors.

Whenever I was invited to his house, he entertained in such a lavish and interesting way. He was part of the inner circle of Easthampton society.

His longtime companion, Edward "Ted" Dragon, was an extremely good-looking man who had been a successful ballet dancer in New York City. He was also a bit of a rascal. When Ossorio had parties for his rich friends, Dragon would break into their houses and steal their jewels.

One time, for Ossorio's birthday, Dragon gave him a most beautiful diamond ring. Ossorio asked him, "Where did you get it?" Dragon told him that it had belonged to his great, great-grandmother. Ossorio very proudly wore the ring. And at one of those lavish parties, with Ossorio wearing this fabulous jewel, Lady Something-or-other recognized the ring as hers—stolen from her house a few months before. It became the scandal of the century out on the end of Long Island.

I enjoyed Ossorio's friendship and was very sad when he passed away in 1990 at the age of seventy-four.

Jean Tinguely, the server of my life . . .

L
JEAN TINGUELY

The Swiss painter and sculptor Jean Tinguely made kinetic art in the Dada tradition, satirizing the materialism of industrial society. As a young man, he moved from Switzerland to Paris in order to pursue a life in art, and he became an important figure in the mid-twentieth-century avant-garde. In 1960, along with Yves Kline, the critic Pierre Restany, Arman, and other artists, he founded the Nouveau Réalisme group in France. His most famous work was a self-destroying sculpture titled *Homage to New York* (which only partially self-destructed at the Museum of Modern Art in New York City in 1960).

I went to Switzerland on the invitation of Jean Tinguely to discuss an exhibition. Tinguely took me to his favorite restaurant in the small town of Fribourg, near Bern. At the restaurant with him I felt like a major celebrity. On our table was a large round loaf of bread, upon which the chef had baked, "Viva la Riva." While enjoying the most incredible food, I observed the interesting eating manners of the Swiss. The women would be served a very small portion while the men would be served three times as much. After the meal, I took the loaf of bread with me, and later someone stole it.

I spent a few days with Tinguely. He looked like a magician and his sculpture was the magic that he performed. He had a big black mustache and thick eyebrows, and his eyes were black and shining. Dressed always in black pants, a white shirt, a black vest, and a scarf, he seemed to have slept in his clothes, or never slept at all. His studio looked like a big scrap metal junkyard.

Tinguely came to Arizona when he was invited to be the grand marshal of the first International Grand Prix in Phoenix. His kinetic sculpture sculpture machines, known as "metamechanics," often had wheels, and he was well known in international racing circles.

During this Arizona trip, he came to see me, carrying in his arms a very small dachshund that he'd brought all the way from Switzerland. He wanted to travel the roads of Arizona with me to collect bones for his next project. On the side roads we found vendors who sold the skulls and bones of cows and horses. He would buy the bones whenever we came across them.

One of Tinguely's many letters to me

Tinguely sent me quite a few letters, which were personal and painted like masterpieces. I still have all of them. He wrote that he loved me. The last letter he wrote was the plan for his Arizona exhibition. He died before it took place.

In 1991, Tinguely was hospitalized in Switzerland with a heart attack. After a week he was better, but they wanted to keep him there for a few more days. I guess he got bored—he invited a nurse to his bed, had sex with her, and died. Caught in the act.

Jean Tinguely was born in Fribourg, Switzerland, in 1925. He died in 1991 in Berm, at the age of sixty-six.

Riva with Tinguely in Switzerland.

Jean Tinguely, sketch for Méta Harmonie IV – Fatamorgana, *1970.*

Jean Tinguely, Méta Harmonie IV – Fatamorgana, *1970.*

My father's last words.

AFTERWORD

I look upon you with the highest degree of admiration and acknowledge your many accomplishments . . . now and forever. As you know, I spent most of my life in Israel, and though I was engaged in industry, my passion was rooted in the arts. I became a patron, and you may remember that our house was always filled with paintings and the artists who painted them. I dreamed that you would pursue a career in the arts, and now I can thank you for fulfilling my dream.

The love of a father for his daughter is an unconditional love and endures for all time. Know that I will be with you wherever you go today and forever.

—My father, Fishel Kilstok (1906-1991)

Marguerite Duras, photo © mediaisla.net.
From http://mediaisla.net/revista/2011/03/el-escritor-su-obra-y-el-lector/.

EPILOGUE

One day, I was already old, in the entrance of a public place a man came up to me. He introduced himself and said, "I've known you for years. Everyone says you were beautiful when you were young, but I want to tell you I think you're more beautiful now than then . . . I prefer your face as it is now."

—Marguerite Duras, *The Lover*

MY OTHER CHILDREN

KEY FOR ARTISTS PAGE ONE

Top row:

1. Jim Waid
2. Philip C. Curtis
3. Françoise Gilot
4. Adolph Gottlieb

Second row:

5. Joan Mitchell
6. Robert Zakanitch
7. Luis Jimenez
8. Hans Hofmann

Third row:

9. Johan Creten
10. Carlo Maria Mariani
11. Manuel Neri
12. Rodolfo Morales

Bottom row:

13. Robert Stivers
14. Helen Frankenthaler
15. Alejandro Colunga
16. Alex Katz

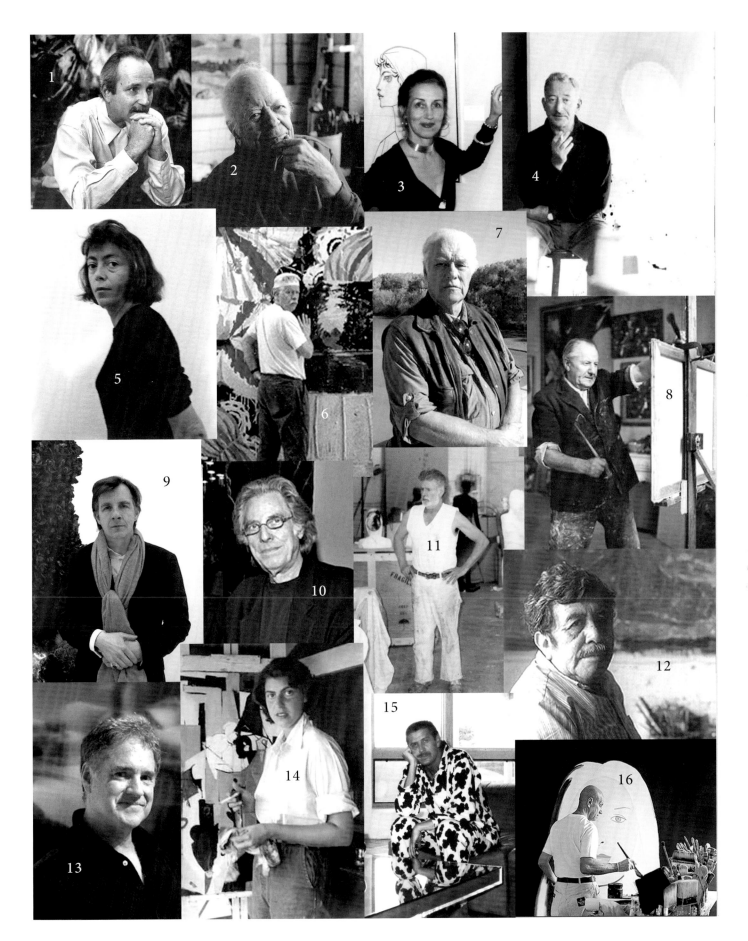

KEY FOR ARTISTS PAGE TWO

Top row:

1. Frank Stella
2. Dorothy Fratt
3. William T. Wiley
4. Nathan Oliveira

Second row:

5. Conrad Marca-Relli
6. Rico Eastman
7. Robert Arneson
8. Elias Rivera

Third row:

9. Richard Anuszkiewicz
10. Robert Motherwell
11. Roberto Márquez
12. Byron Browne

Bottom row:

13. Fernando Botero
14. Paul Pletka
15. Jeff Overlie
16. Turner Davis

Diego.

MY OLD BEST FRIENDS

Frida looking for Diego.

Like Tutu, I will never forget.
　　　　　　　　—Riva

My life is one big circle with no end.